IMAGES OF AMERICA

MANASSAS
A PLACE OF PASSAGES

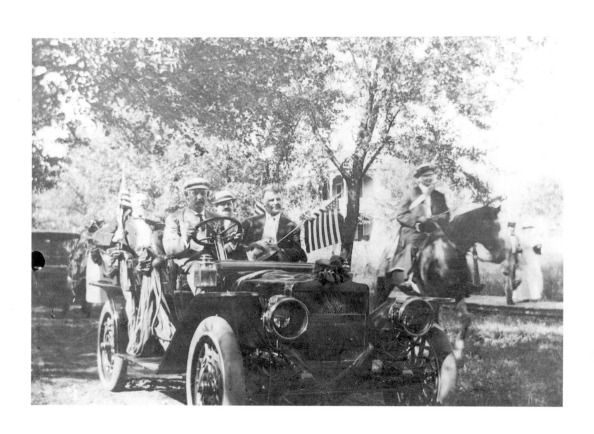

IMAGES OF AMERICA

MANASSAS
A PLACE OF PASSAGES

KATHLEEN MULVANEY
THE MANASSAS MUSEUM SYSTEM

ARCADIA

Frontispiece: Grant Avenue, perhaps Manassas' most picturesque street, is the perfect place for a parade. Constructed in 1895 with the opening of the Prince William Courthouse, this tree-lined road features many large and beautiful homes. Although the exact date and reason for this parade are uncertain, the flags and car suggest a patriotic occasion in the early part of the twentieth century. Sitting in the rear of the car, holding a flag, is Confederate veteran and well-known citizen Westwood Hutchison.

Copyright © 1999 by The Manassas Museum Associates
ISBN 0-7385-1559-0

First published 1999
Re-issued 2003

Published by Arcadia Publishing
an imprint of Tempus Publishing Inc.
Charleston SC, Chicago, Portsmouth NH,
San Francisco

Printed in Great Britain

Library of Congress Catalog Card Number: 2003107146

For all general information contact Arcadia Publishing at:
Telephone 843-853-2070
Fax 843-853-0044
E-mail sales@arcadiapublishing.com
For customer service and orders:
Toll-Free 1-888-313-2665

Visit us on the internet at http://www.arcadiapublishing.com

Contents

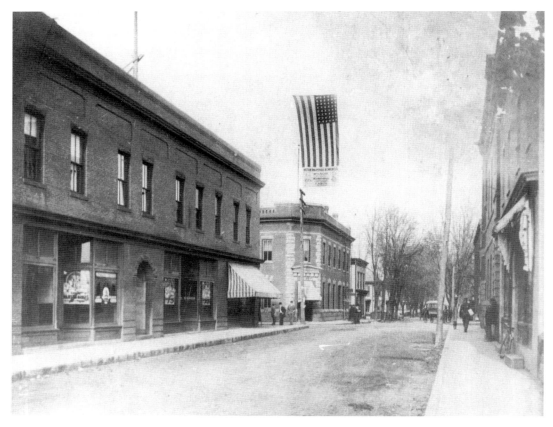

During the 1912 presidential election, a political banner hung on the corner of Battle and Center Streets, supporting the Democratic ticket. The banner reads, "Wilson, Marshall & Carlin Club." The ticket included Woodrow Wilson for president, Thomas Marshall for vice president, and Charles Carlin for Congress.

Introduction

No one knows for certain how the city of Manassas got its name. Many have speculated as to its origin, and several competing theories have co-existed for generations. Some believe it is a Native American term. Local lore suggests "Manassa" was the name of a French-Jewish innkeeper in the Shenandoah Valley near Manassas Gap. Those familiar with the Old Testament argue it is a biblical reference to two kings named Manasseh. Little concrete evidence exists to support any one theory.

The lack of information on the name's origin is very telling of the community known today as Manassas. Unlike other towns that can point to definitive founding dates, Manassas does not have such a moment. Manassas and its surrounding area, known as the Northern Virginia Piedmont, were settled initially more by chance than by design.

The Piedmont has always been a place of passages—an in-between place on the way to somewhere else. The first inhabitants were Native American groups, who migrated between the eastern Tidewater region and the Shenandoah Valley, prior to European immigration. Archaeological evidence suggests that the Manahoacs were the largest Native-American group to inhabit the Piedmont, but due to their transitory nature very little is known about them.

The history of the Piedmont, Prince William County, and Manassas becomes a bit clearer in the eighteenth century. Documentary evidence indicates that in 1724, Robert "King" Carter patented the Lower Bull Run Tract, which included much of present-day Manassas and western Prince William County. Carter's descendants established plantations and farms on the Piedmont. For much of the eighteenth and early nineteenth centuries, landed gentry, yeoman farmers, slaves, and free African Americans worked the land.

Life on the Piedmont changed dramatically in the 1850s when two railroads, the Orange & Alexandria and the Manassas Gap, ran lines through the area. For the first time, goods and people could be transported easily to lands near and far. The two lines met in central Prince William County, forming a junction near a small cluster of buildings known as Tudor Hall. The name Tudor Hall quickly became Manassas Junction, and then simply Manassas. A new sense of promise stood on the horizon for the residents of the Northern Virginia Piedmont and the little town at Manassas Junction.

Unfortunately for Piedmont residents, the sectional struggle between North and South deferred regional growth and prosperity. Instead of crops, the railroad soon carried war supplies and Civil War soldiers. Manassas Junction was a key strategic point along the only continuous railroad connection between Washington, D.C., and the Confederate capital of Richmond, and both sides sought to hold it. Additionally, control of Manassas Junction equaled control of the rail lines to the Shenandoah Valley. The existence of the railroad made the battles and destruction that occurred throughout the Piedmont inevitable.

During the course of the Civil War, the two opposing armies battled twice near Manassas. On July 21, 1861, Federal troops from Washington attacked Confederate forces along a creek called Bull Run, five miles northwest of Manassas Junction. The Confederates won the battle they called First Manassas; to the Union it was First Bull Run. The armies met again on the same ground on August 29 and 30, 1862. Like the first engagement, the Confederates prevailed at the Second

Battle of Manassas. After each battle, the Confederates left Manassas, but not before completely destroying the Junction and everything within miles of it. For the rest of the war, Federal troops held the Junction and forced most residents to leave the area.

When the war was over, former residents returned to the Piedmont and Manassas to find little left of their homes, farms, and businesses. While the war had obliterated everything that was once Manassas, a bigger, more prosperous town blossomed out of the destruction. By the end of the 1860s, trains once again roared through the Piedmont, and former residents and newcomers from the North banded together to rebuild and improve Manassas. Houses, schools, stores, hotels, and restaurants sprang up quickly around the Junction. Agriculture remained the primary industry in the area, but a new town was growing.

The late nineteenth century saw significant achievements for Manassas in education and government. The first public school in Prince William County, the Ruffner School, opened in 1872. In 1894, a former slave named Jennie Dean led great strides in African-American education by opening the Manassas Industrial School for Colored Youth, an academic and trade high school. On the government side, the Town of Manassas officially incorporated in 1873, and in 1892 became the seat for Prince William County.

As the twentieth century dawned, Manassas, still an agricultural community, became an important source of produce and dairy goods for Washington, D.C. Also at this time, Manassas took its first steps toward becoming a suburb of the nation's capital, as residents began commuting to work in the federal city by train. After World War II, the essence of Manassas began to change as local families sold off farms they had owned for generations to make room for more houses, shopping centers, and industry. By the 1960s and 1970s, the rural nature of Manassas had been altered forever. In 1975 the Town of Manassas was chartered as a city, becoming an independent governmental entity separate from Prince William County. Today Manassas is a 10-square-mile city of nearly 35,000 people, a far cry from the several hundred who lived in the town during the early twentieth century. Many of the residents are new to the area, making their homes in Manassas, but working in other parts of Northern Virginia and Washington, D.C. New high-tech corporations are bringing industry and jobs to the area, continuing the western extension of densely populated, highly developed Northern Virginia.

Even as Manassas grows and changes, traces of its past are still evident. Today, as throughout its history, the people of Manassas make it an interesting and unique place in which to live. This book reveals in pictures both the people and places of Manassas from the 1860s through the middle part of the twentieth century. Rather than presenting a comprehensive historical narrative, the book highlights major themes of the region's development. The result is a representative collection of windows into the past, evoking memories of longtime residents while also introducing newcomers to the community's proud heritage.

The majority of the photographs are from The Manassas Museum's McBryde Library and Archives. Included in the book and the Museum's collections are photographs taken by Howard Churchill, a photographer in Manassas from the 1940s to the 1970s. The following institutions and collectors also provided photographs: the Library of Congress, the National Archives, the United States Army Military History Institute, the Western Reserve Historical Society, and the private collections of Ann Harrover Thomas, Lewis and Rosalie Leigh Jr., William F. Merchant, and Georgia Peters Goodwin.

This book is a product of The Manassas Museum System and The Manassas Museum Associates. The Museum System, a department of the City of Manassas, is dedicated to collecting, preserving, and interpreting the history of Manassas and the Northern Virginia Piedmont. It consists of seven sites: The Manassas Museum; the Manassas
Industrial School/Jennie Dean Memorial; the Manassas Railroad Depot; the historic house "Liberia"; the Mayfield and Cannon Branch Civil War Earthworks; and the Hopkins Candy Factory Arts Center.

Everything Here is New

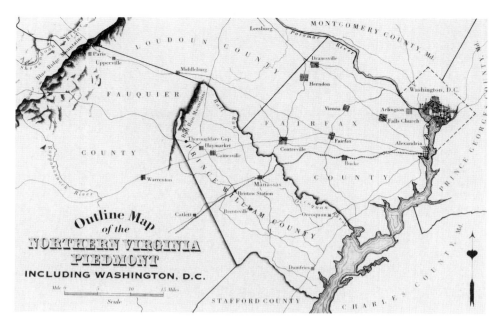

Manassas is located in the Northern Virginia Piedmont, the rolling countryside at the base of the Blue Ridge Mountains rising to the west. Located in historic Prince William County, the City of Manassas lies in 30 miles southwest of Washington, D.C., and 30 miles east of the Shenandoah Valley.

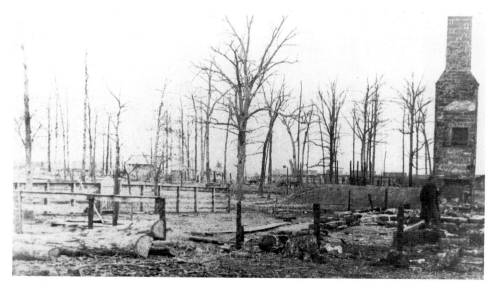

The Civil War brought almost complete destruction to Manassas Junction and its surrounding farms. Many former residents, forced out during the war, returned in 1865 to find nothing left of their homes and farms except an occasional chimney or fence. Although disheartened by the charred landscape, the former residents moved beyond the destruction and began rebuilding their houses and farms. Eventually, a larger town, known simply as Manassas, developed near the junction of the railroad. (Courtesy of Lewis and Rosalie Leigh Jr.)

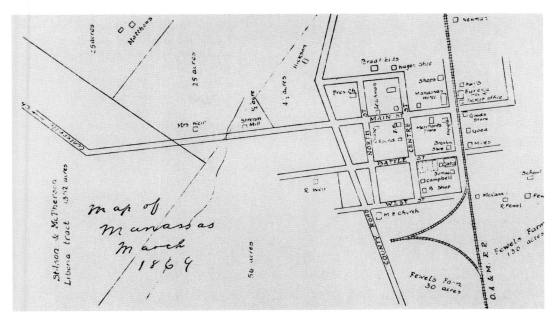

By 1869, a mere four years after the Civil War had ended, the little village near the railroad junction was reborn and growing. William S. Fewell, a landowner in the area, laid out the first section of town in 1865. He then went on to sell off his land for community growth. Surrounded by farmland, the village of Manassas boasted several homes as well as a school, two churches, and two hotels. The railroad, a tool of war a few years before, once again provided area residents with a way to transport people and goods. Several stores, catering to area residents as well as to railroad workers and travelers, appear on the map. Newcomer George Carr Round captured the essence of the town's emergence when he observed, "Everything Here Is New."

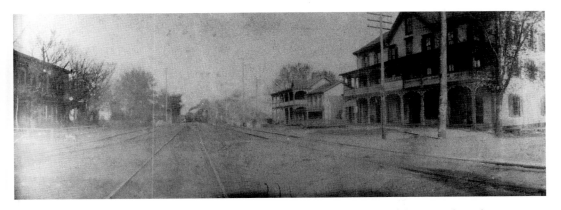

By about 1900, Manassas contained no less than four hotels. This view, looking east from the Main Street railroad crossing, shows on the left side of the tracks the Goodwin House (formerly the Manassas Hotel) and on the right side the Keyes House, the Eureka Hotel, and the Hotel Maine (formerly the Cannon House). In the years before dining cars, trains commonly stopped at hotels along the way for passengers to eat.

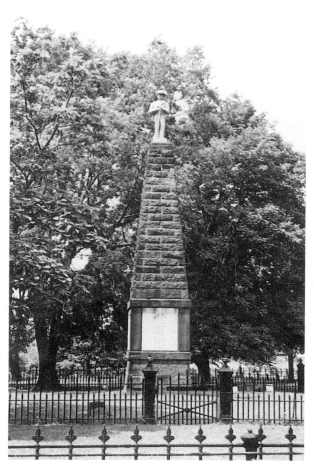

Left: Concerned by the unknown dead Confederate soldiers buried on farms around Manassas, a group of women called the Ladies Memorial Association of Manassas banded together in 1867 to create one Confederate Cemetery. By 1889 they made a common grave containing 250 soldiers and erected atop it a sandstone monument. Within three years they put the final touch on the monument, a bronze statue of a Confederate soldier. The Confederate Cemetery is today part of the Manassas City Cemetery.

Below: For most of its history, one word could sum up life in Manassas —agriculture. Beginning with the first European settlers in the late eighteenth century, farming was the principal occupation of most families in the area. Early on, much of the land produced grains, but by the late nineteenth and early twentieth centuries, dairy farming had taken hold in Manassas. Farms, like Liberia, seen here c. 1900, produced milk and other dairy products for sale in the Northern Virginia and Washington, D.C. markets. Agriculture continued to be the primary industry in the Manassas region well into the mid-twentieth century.

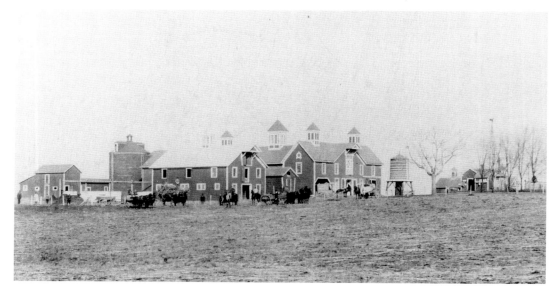

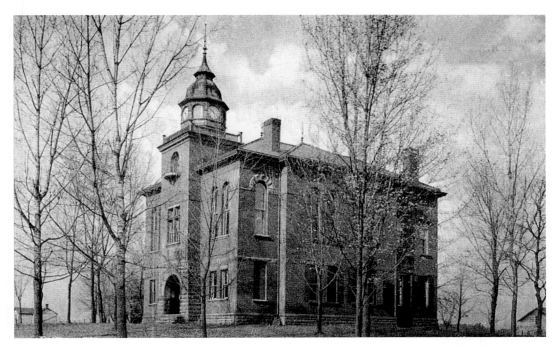

While still in its infancy, the Town of Manassas aspired to greater spheres of power. In 1872 the eternally optimistic citizenry of Manassas sought to become the county seat for Prince William. They lost out that year and again in 1888 to Brentsville but refused to give up. Finally, in 1892, the citizens won, and Manassas, largely because of its proximity to the railroad, became the county seat. On the west side of town, the county built a stately new courthouse of sandstone and brick as well as a jail. In 1911, the courthouse hosted the Manassas National Jubilee of Peace, a significant event at which President William Howard Taft addressed Civil War veterans. The courthouse held the county offices and courts until a new complex replaced it in 1984. Although Manassas is an independent city and no longer part of Prince William County, the county complex sits within the city's limits.

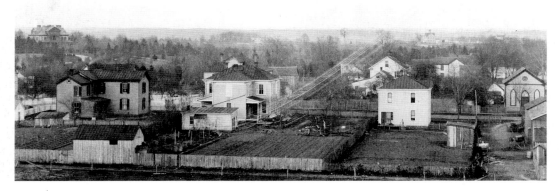

H.D. Wenrich, an early photographer of Manassas, took this picture c. 1900 from the top of the courthouse. The view looks east toward the backs of the houses on West Street, with the Portner home, "Annaburg," in the left background and the Prescott barn in the right background.

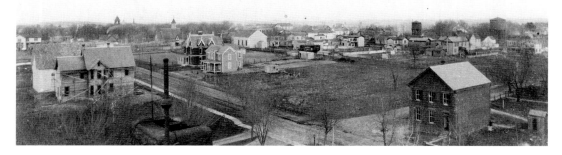

Mr. Wenrich also took this picture from the courthouse at the same time as the one above. He aimed his camera southeast, toward the intersection of Lee and Grant Avenues. At the left is the Lutheran parsonage under construction, and in the center is the Asbury Methodist-Episcopal Church.

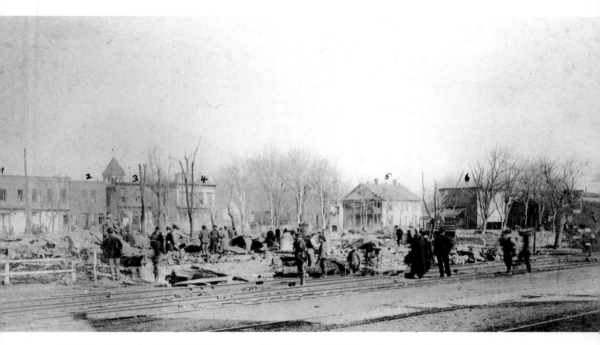

Fire! On December 5, 1905, Manassas suffered its greatest destruction since the Civil War when fire swept through the business block bordered by Main, Center, and Battle Streets and the railroad tracks. Although the official cause of the fire was never fully determined, local lore says that someone left a lit match in the outhouse opposite the train depot, and it slowly turned into a blaze. Even though the fire caused extensive damage, the businesses rebuilt. After the fire, owners constructed more substantial structures made out of brick, stone, or concrete, as required by new building codes. As early as May of 1906, the local newspaper, the Manassas Journal, reported the burned area to be a scene of much activity and development.

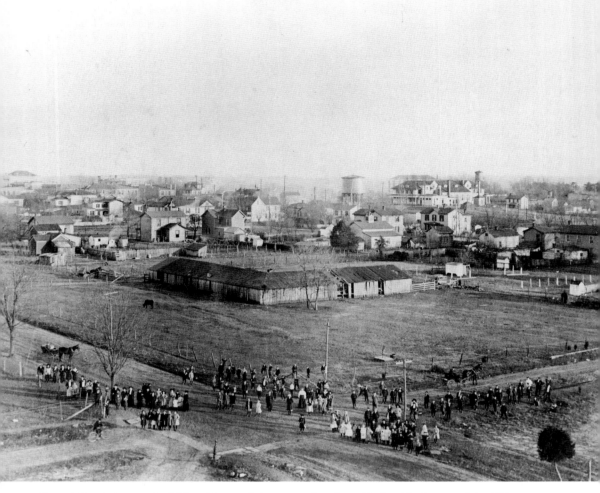

Above: What is the occasion? The citizens of Manassas gathered outside for this photograph in 1909 or 1910; however, the moment or event they were marking remains a mystery. To attain this southeastern aerial view, the unknown photographer stood at the top of the original Bennett School on Lee Avenue. It is possible that the group came together to mark the completion of the school in 1909. No matter the reason, the photograph provides a wonderful view of the town. Many of the landmarks of the day can be seen in the background of the photograph, including the first Prince William Hotel, Swavely School, and the train depot.

Opposite above: Aptly named, Center Street runs though the middle of town. In 1910, when this photograph was taken, Center Street stood at the heart of the Manassas business district. It boasted stores as well as entertainment centers, such as the Conner Opera House, and accommodations, such as the second Prince William Hotel. The telephone lines indicate that modern technologies were beginning to come to town.

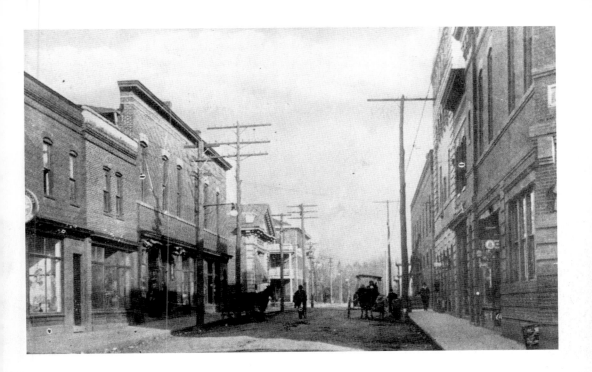

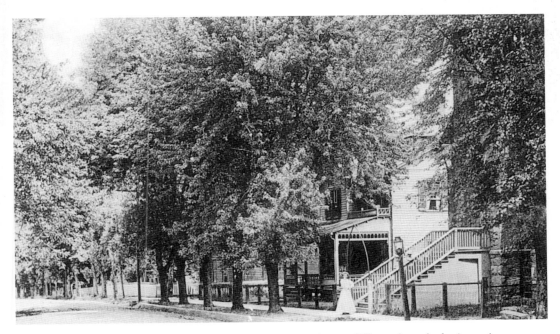

Just a block away from Center Street, this c. 1910 scene is very different from the business view. Residential areas featured tree-lined roads with neatly kept houses behind beautifully fenced-in yards. Here an unidentified woman stands on the corner of Main Street near the Presbyterian church.

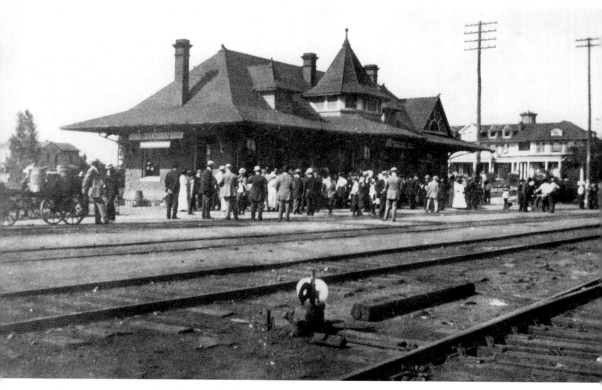

Nothing has shaped the landscape of Manassas more than the railroad. People, homes, and businesses have come and gone, but the railroad has always remained. As a result, the railroad depot, seen here in the first decade of the twentieth century, has long been a focal point for the town. The sounds of locomotive whistles and crossing bells have greeted Manassas residents and visitors day in and day out for more than a century.

Opposite: Less than a decade after the Civil War, Manassas had grown far beyond its prewar limits, and the citizens decided to incorporate. On April 2, 1873, the General Assembly of Virginia created the Town of Manassas in Prince William County. The town was about one-half mile square and straddled both sides of the railroad tracks. The government structure in 1873 consisted of a mayor, sergeant, clerk, and seven council members. This format lasted until 1926, when Manassas adopted a town manager form of government. In 1975, Manassas again changed its governmental status by separating from Prince William County and becoming an independent city. To accommodate the growing town's governmental needs, Manassas erected its first town hall in 1914. Local architect and resident Albert Speiden designed the building to serve
dual functions as a council chamber on the upper floor and the fire station on the lower level. In this 1914 photograph, the mayor and town council stand with Speiden in front of the newly opened building.

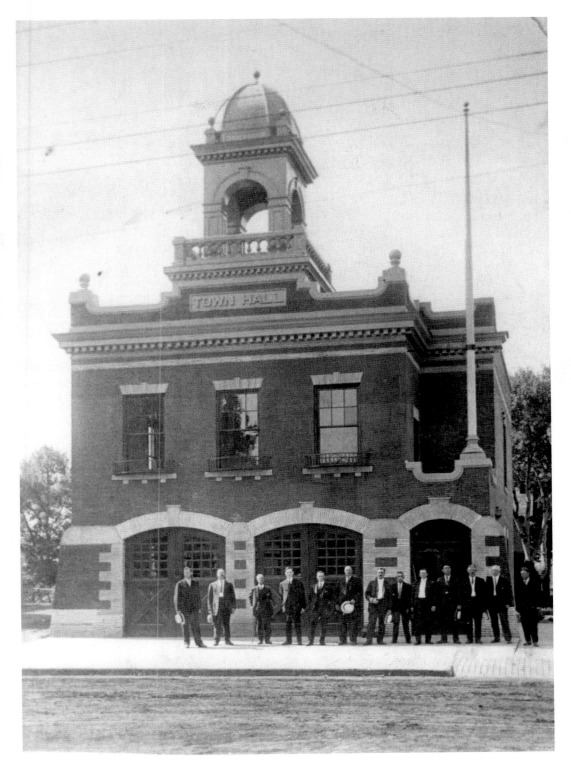

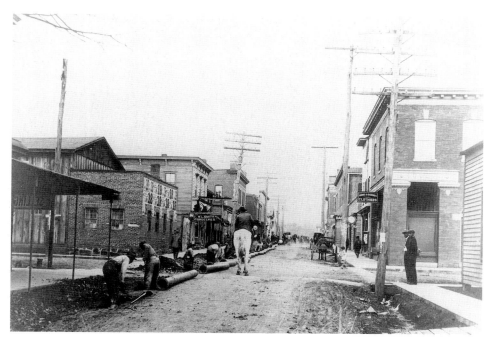

In 1914 and 1915, the dirt streets of Manassas, like Center Street shown here, were a mess. All over town, men were digging up the roads and installing much-desired water lines. As early as 1898, Manassas residents sought the installation of light and water systems, but not until June 18, 1913, did the town council approve a new bond issue for water, sewerage, and electric systems. Paved streets came along in 1922.

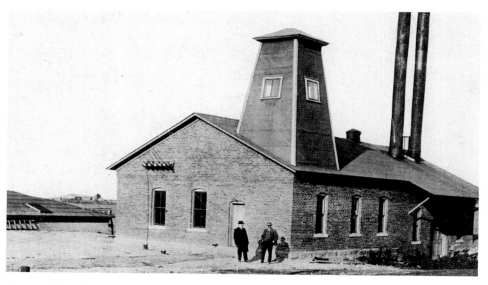

As part of the effort to provide the town with public utilities, Manassas built this powerhouse for electric and water systems at the end of east Church Street in 1914. In June of that same year, the town created the office of superintendent of public works to oversee public utilities. George L. Rosenberger served as the first superintendent.

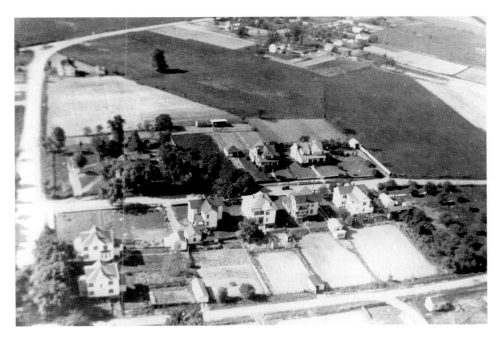

By 1936, Manassas had grown tremendously from post–Civil War days. The rhythms of this small town, surrounded on all sides by agriculture, had been set years before. This aerial photograph depicting the well-ordered homes and farms in the Manassas area shows Church Street in the foreground, Quarry Road in the center, and Centreville Road in the background, bounded by Prescott Avenue on the left.

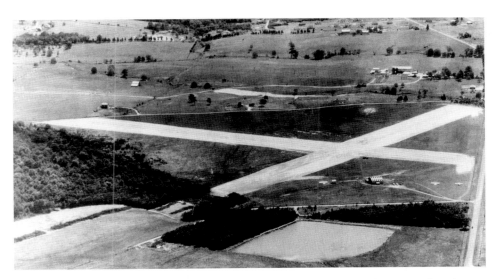

Always looking toward the future, Manassas officials and citizens saw the advantages of an airport early on. In June 1932, the Manassas Landing Field opened on land that was part of the Ben Lomond farm along Route 234. The airport, seen here in the 1950s, most often carried freight and mail. A new facility, located 4 miles west of town, replaced this airfield in 1964. The original airport site now holds the Manaport Shopping Center.

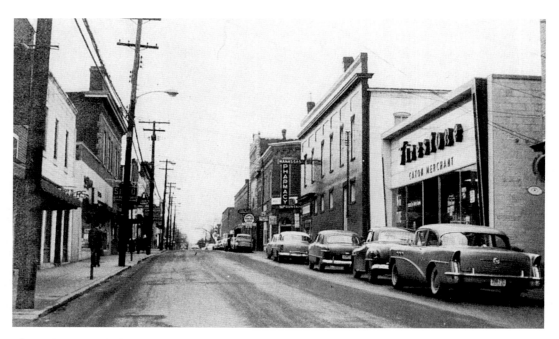

The roads are paved, the telephone poles are more numerous, and cars line the street, but Center Street in the 1950s looks remarkably like it did at the beginning of the twentieth century. While many of the businesses from earlier in the century still existed in the 1950s, new businesses, such as the Caton Merchant Firestone, speak to the future of Manassas as an automobile town. For two decades after this photograph, the downtown suffered, as many of the businesses moved to Sudley and Centreville Roads. In the 1990s, community and business leaders revitalized the older business district, known as "Old Town Manassas," and it again features a variety of shops, restaurants, and The Manassas Museum.

two

A Community
at War

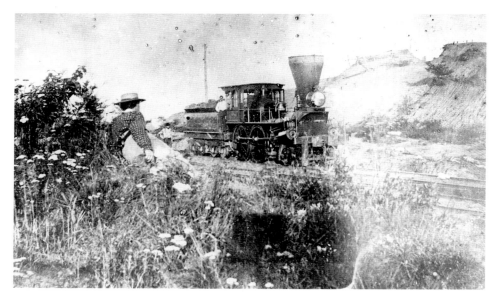

In the 1850s, a train whistle in the distance signaled promise and prosperity to residents of the Northern Virginia Piedmont. Little did they realize that a few short years later the railroad would bring just the opposite—desolation and destruction. Unfortunately for the little village at the junction of the Orange & Alexandria and Manassas Gap Railroads, it was a key point along the only continuous railroad connection between Washington, D.C., and Richmond. The Junction also provided rail access to the Shenandoah Valley. As a result, the railroad brought soldiers, supplies, and the Civil War to Manassas in 1861. No photographs record the railroad until 1862, after the Confederates left the area and Union troops arrived. In 1862, photographer Timothy O'Sullivan, one of Mathew Brady's assistants, captured this Orange & Alexandria locomotive in front of a Confederate fort located at present-day Grant Avenue and Prince William Street. (Courtesy of the Library of Congress.)

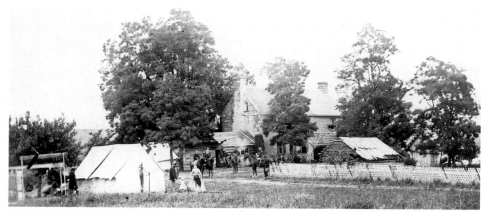

Like most Piedmont residents, the Duncan family saw the Civil War literally enter their home. The 1834 structure experienced occupation by both sides. When this photograph was taken on July 4, 1862, Colonel Lewis Burton Pierce of the 12th Pennsylvania Infantry had his headquarters in the house, which Union soldiers called "Yellow Hospital." The house survived the war and passed to the Conner family. (Courtesy of the Library of Congress.)

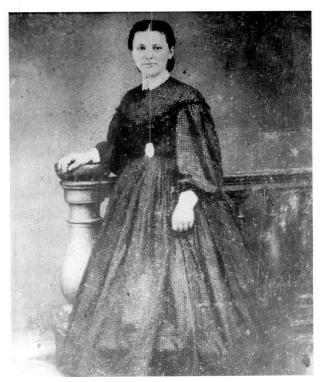

The Civil War touched every resident of the Piedmont, regardless of gender, age, or race. Mary Virginia Conner was a young woman, who, during the war's optimistic first days, cheered Confederate soldiers as they marched through nearby Brentsville. Family tradition holds that some soldiers plucked buttons from their uniforms and presented them to her. Little did Mary Virginia realize how drastically the lives of everyone she knew would change over the next four years.

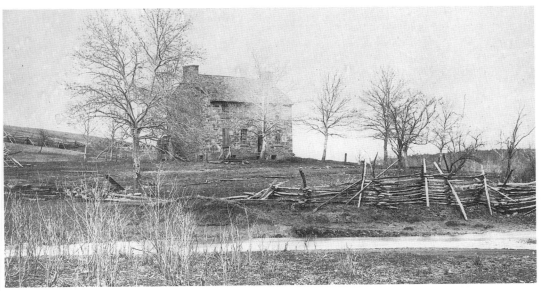

The Stone House, built in the 1820s, started its life as a tavern along the Warrenton Turnpike. It gained fame as a Civil War hospital during both the First and Second Battles of Manassas. While the battles raged around it, the thick walls of the Stone House protected wounded soldiers and the surgeons working to save lives. The house stands as the most recognizable building at the Manassas National Battlefield Park. (Courtesy of the National Archives.)

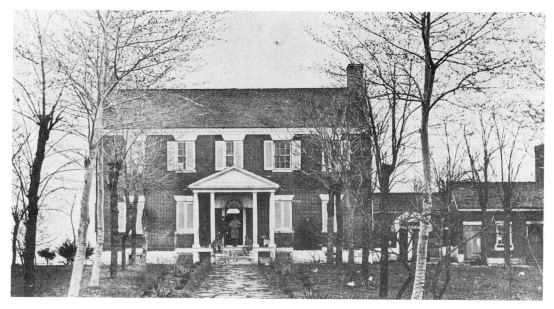

Manassas' most historic home, "Liberia," was used by both sides during the war. Following the
First Battle of Manassas, Confederate General P.G.T. Beauregard used "Liberia" as his headquarters.
At the time of this photograph in 1862, Union General Irvin McDowell occupied the home for the
same purpose. President Abraham Lincoln visited McDowell at "Liberia" on June 19, 1862. The
house survived the war and today is part of The Manassas Museum System. (Courtesy of
MOLLUS/USAMHI.)

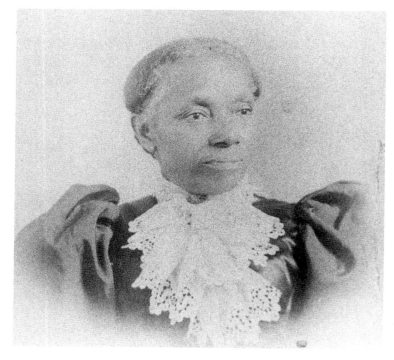

Emma Chapman was
born into slavery. Like
some 2,000 other slaves
in Prince William
County, Emma had to
decide during the Civil
War whether to stay at
the only home she had
ever known or flee to
freedom elsewhere.
Emma remained with
her former owners, the
Johnsons, at their farm
"Clover Hill," working
for them until her death.

Until Emancipation, most slaves lived in wooden cabins located some distance from their owners' dwelling. This slave cabin on the Johnson family's farm, "Clover Hill," is unusual for its stone construction and because the Johnsons themselves lived in it. The family took refuge in the small building while constructing a new house to replace the one destroyed during the war. The cabin survives today off Wellington Road.

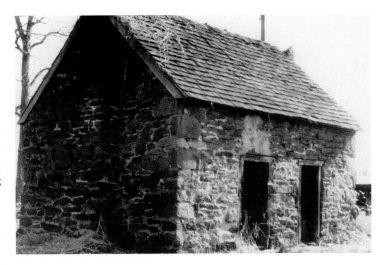

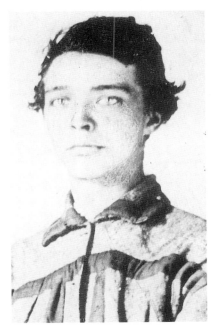

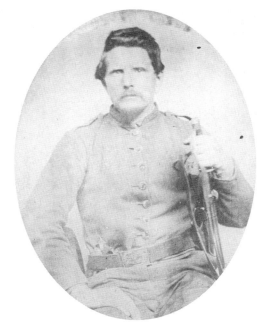

Above, left: Many young men of the Piedmont heard the call to defend their land and the newly formed Confederacy. Most of them had never gone far from the farm, let alone into battle. Alexander H. Compton, a Prince William County native, little more than 20 years old, was one of these men. Compton joined a local unit, Company A, 8th Virginia Infantry. He fought throughout the war and survived to return home and start his life anew.

Above, right: Amos Benson found the war inescapable. Two days after the First Battle of Manassas, Amos and his wife, Margaret, discovered John L. Rice, a wounded Union soldier, lying in a field near their farm. Believing him too ill to move, the Bensons nursed him in the field for ten days until he could be taken to the hospital at Sudley Church. After the war, Rice repaid his debt by helping raise money to rebuild the destroyed church.

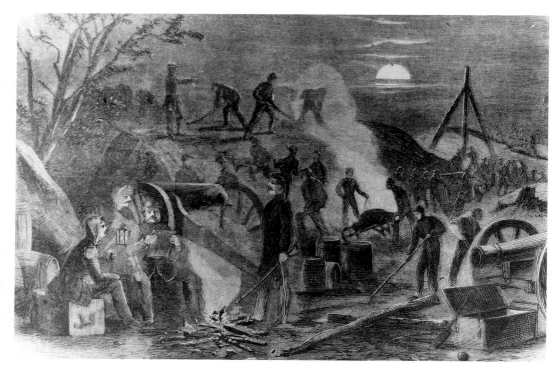

Harper's Weekly, in their August 10, 1861 issue, ran this engraving of South Carolina troops building earthworks at Manassas Junction by moonlight. The importance of controlling the Junction was clear to both the North and South by early 1861. In May of that year, the Confederates began laying out fortifications in preparation for the battles to come. The Confederates used not only their men to build fortifications, but also slaves from local farms.

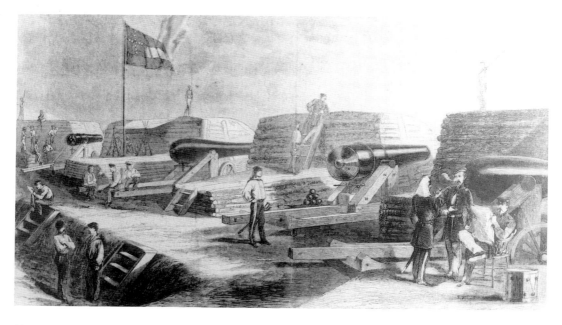

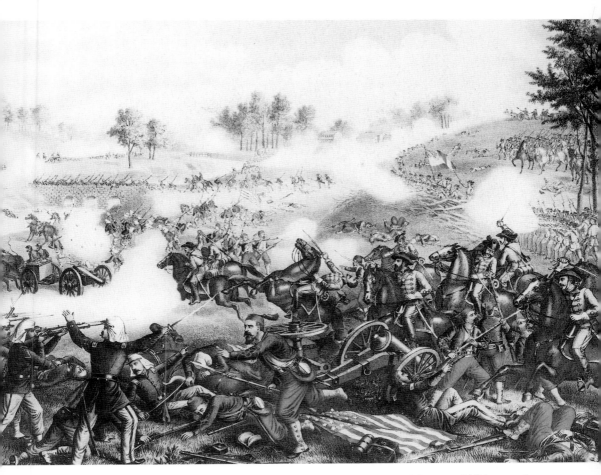

Above: On the morning of July 21, 1861, musket and cannon fire shattered the peaceful life around Manassas. For seven horrifying hours, North and South fought across the fields 5 miles northwest of Manassas Junction. It was the first major engagement of the Civil War and became known as the First Battle of Manassas (Bull Run). Both sides entered the fighting believing it would be the only battle of the war. Civilians from Washington, D.C., came out with picnics to watch the great battle that would crush the rebellion. The Confederates won the day, but 4,626 men were left dead, wounded, captured, or missing. This lithograph depicting the Battle of Bull Run is based on a sketch made by Louis Kurz during the war. Kurz & Allison of Chicago included it in a set of 36 color lithographs in 1889. The lithographs are noted more for their color and drama than for their historical accuracy.

Opposite, below: Land-locked Manassas seemed an unlikely place to find a naval battery, but in July 1861, cannon captured at the Norfolk Navy Yard stood ready to defend Manassas Junction. In this September 14, 1861 sketch, *Harper's Weekly* documented the naval cannon and Confederate sailors guarding Manassas.

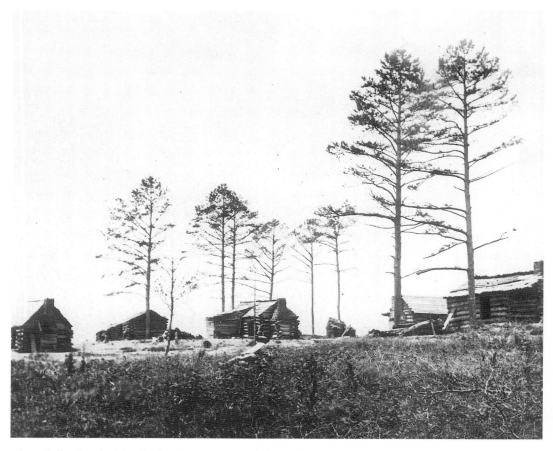

Above: Following the First Battle of Manassas, Confederate forces controlled the Junction from July 1861 to March 1862. As winter approached, the Confederates built small log and mud huts. Each hut, which featured at least one fireplace and a variety of crudely crafted furniture, housed between four and ten men. Though these cabins were by no means luxurious, they offered soldiers welcome shelter from the cold and snow. In March 1862, the Confederates evacuated Manassas, moving south to defend Richmond. To keep their supplies from aiding the oncoming Union Army, they burned whatever they could not take. The Confederates, however, did not destroy the winter quarters when they left, and Union soldiers took them over. (Courtesy of the Library of Congress.)

Opposite, above: Fortifications and winter quarters survived the Confederate retreat in 1862, but supplies and the railroad met with a different fate. This photograph shows the large-scale destruction of Manassas Junction in 1862. Visible in the rubble are remains of bake ovens, kegs, wagons, butchered steers, and a mule. (Courtesy of MOLLUS/USAMHI.)

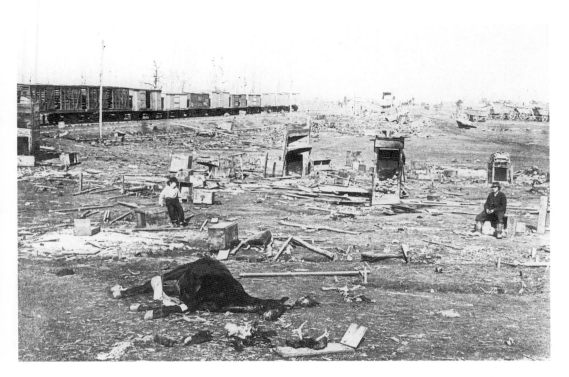

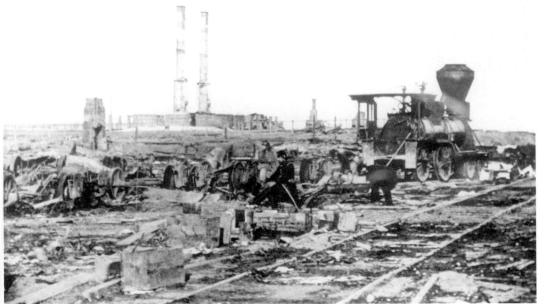

Before the Confederates left Manassas, they disabled the railroad. As a result, Union troops arrived in March 1862 to this scene of destruction. The Confederates damaged the railroad tracks and crippled all locomotives and rolling stock they left behind. The various chimneys in the background suggest that several buildings also met with their end before the Confederates withdrew. (Courtesy of MOLLUS/USAMHI.)

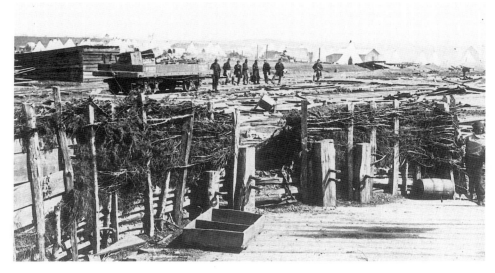

This scene provides a good perspective on the various elements of the Junction when the Union troops arrived—the remaining fortifications, the disabled railroad, and the destroyed supplies. In the background, Union soldiers have set up camp in Sibley tents. These tents accommodated about 12 men, who slept in a circular layout. The tents' central chimneys and evenly distributed heating made them popular. (Courtesy of MOLLUS/USAMHI.)

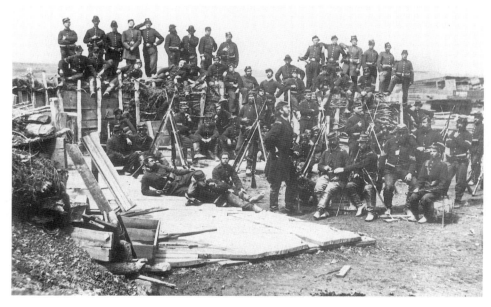

The 41st New York Infantry, Company C, pictured here at the Junction under the command of Captain Knipschild, set out in July 1861 for the First Battle of Manassas. They were too late. On their way they encountered the Union Army retreating back to Centreville. The 41st did come to the Junction in March 1862 for the Union occupation and later fought in the Second Battle of Manassas. (Courtesy of MOLLUS/USAMHI.)

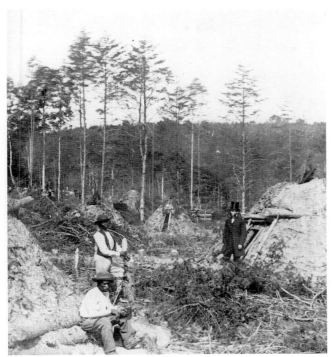

Left: Wood was the fuel that drove Civil War locomotives, and someone had to cut it. These men did just that, working as wood cutters along the Orange and Alexandria Railroad for the Union Army. Almost exclusively African Americans, they lived in crude, pole and sod huts in the forest where they worked. (Courtesy of the Western Reserve Historical Society, Cleveland, Ohio.)

Below: As quickly as the Confederates destroyed the railroad, the Union rebuilt it. The locomotive Fred Leach of the United States Military Railroad ran along the Orange & Alexandria line. The Union gained control of the Orange and Alexandria in March 1862 and operated the line until the war's end, despite periodic disruption by Confederate raiders. (Courtesy of the Western Reserve Historical Society, Cleveland, Ohio.)

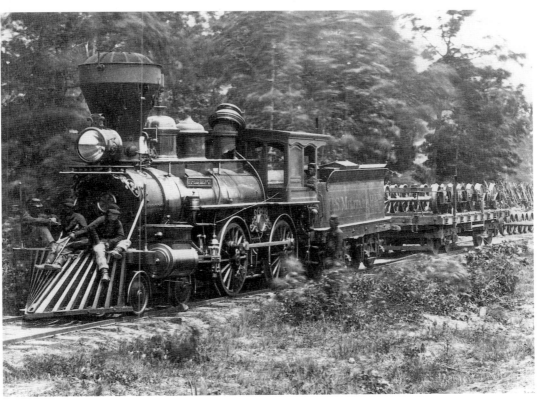

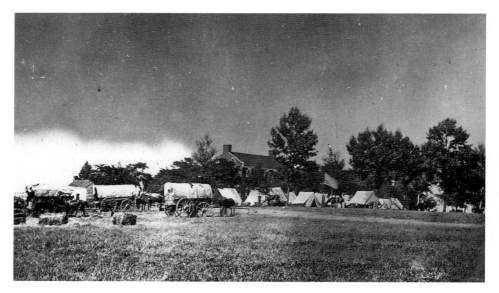

In June 1862, Union General Irvin McDowell, commander during the First Battle of Manassas, set up headquarters at "Liberia." Previously used as Confederate General Beauregard's headquarters, the Confederates spared the house during their evacuation in March 1862. In this photograph, "Liberia" and the encampment of McDowell's personal guard are barely visible through the trees. (Courtesy of the Library of Congress.)

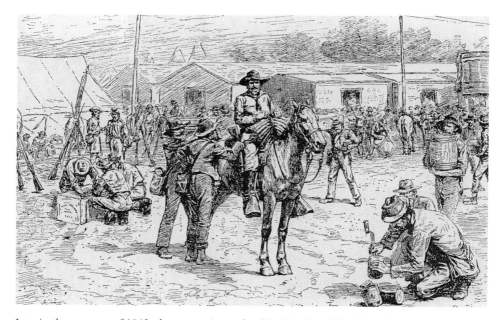

Late in the summer of 1862, the war again escalated in Northern Virginia and at Manassas Junction. On August 27, just prior to the bloody Second Battle of Manassas, General Thomas J. "Stonewall" Jackson raided the Union supply depot at Manassas Junction. After several days of fighting, 20,000 men lay dead or wounded. The Confederates won the battle known as Second Manassas. This sketch shows Jackson's troops raiding the Junction.

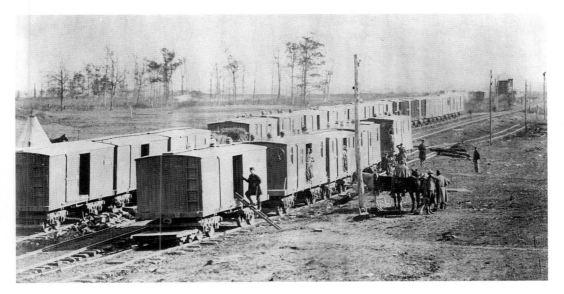

Modern technology made the Civil War different from any war that preceded it. The railroad transported troops and supplies, and the telegraph transported messages. This train served as a telegraph station for the Union armies at Manassas Junction. Insulators for the wires are visible on top of the boxcars and on poles along the tracks. (Courtesy of the Library of Congress.)

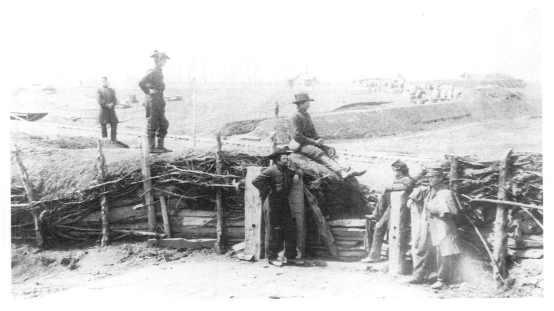

Following its victory in August 1862, the Confederate Army moved on, leaving Northern Virginia to the Union for the rest of the war. Federal soldiers continued to use the fortifications remaining from previous occupations. This photograph shows the inside of one of the earthworks near present-day Prescott Avenue. The soldiers are seated on a platform where a cannon would have been placed. (Courtesy of MOLLUS/USAMHI.)

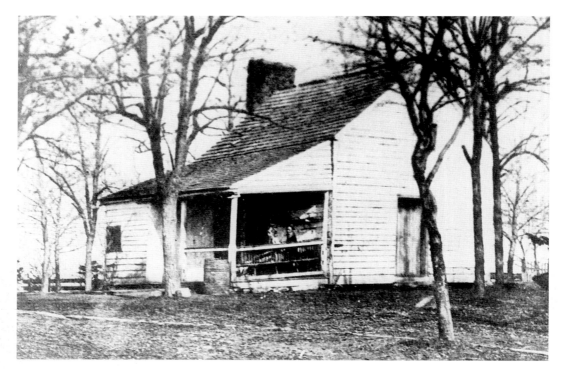

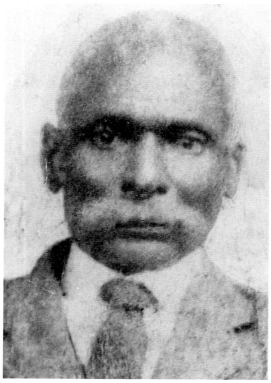

Above: James Robinson, a former slave, became the owner of much of the land that now comprises the Manassas National Battlefield Park. His home, pictured here in the early twentieth century, was in the direct line of advancing Confederate forces during First Manassas. In 1940, Robinson descendants sold their land to the United States government to form the Battlefield Park.

Left: James Montgomery Peters, like many of his neighbors in Manassas, was a veteran of the Civil War. When the war ended, he returned to Prince William County to farm. Unlike many of his neighbors, however, Peters was born a slave. In 1863, he joined the Union Army and fought with the 1st United States Colored Infantry. This photo from the early 1900s shows Peters near the end of his life. (Courtesy of Mrs. Georgia Peters Goodwin.)

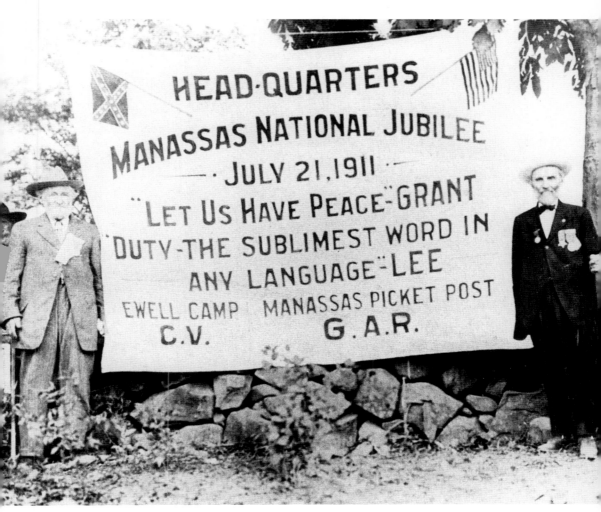

HEAD·QUARTERS
MANASSAS NATIONAL JUBILEE
·· JULY 21,1911 ··
"LET US HAVE PEACE"-GRANT
"DUTY-THE SUBLIMEST WORD IN
ANY LANGUAGE"-LEE
EWELL CAMP MANASSAS PICKET POST
C.V. G.A.R.

Known to history as a place of war, Manassas became a place of peace. On July 21, 1911, 50 years after the battle that first brought it fame, Manassas played host to over 1,000 veterans, who gathered in the spirit of friendship and reconciliation. More than just a celebration of old memories, the Manassas National Jubilee of Peace symbolized the willingness of both sides to put the past behind them and move forward into the new century. The Peace Jubilee involved many events both in Manassas and at the battlefield. This photograph taken at the Jubilee's battlefield headquarters features on the right, George Carr Round, chairman of the event, and on the left, Lieutenant Colonel Edmund Berkeley. Round served in the Union Army Signal Corps and Berkeley was commander of the Confederate 8th Virginia Infantry.

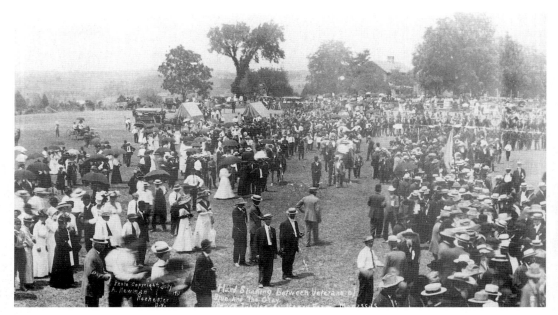

Photo Copyright July
A. Newman 1911
Rochester
N.Y.

Hand Shaking Between Veterans of
Blue And The Gray

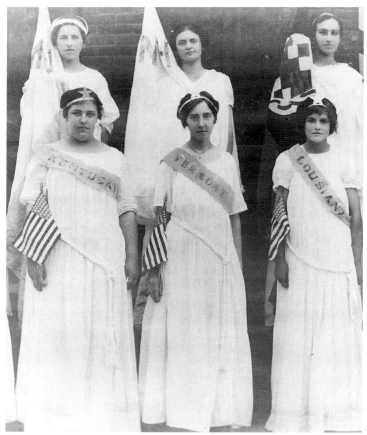

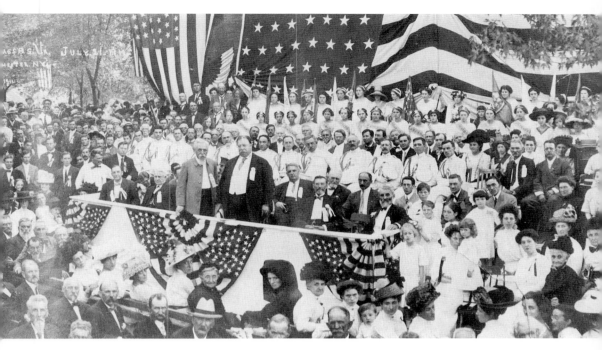

Above: By the end of the day on July 21, 1911, emotions were running high. The Peace Jubilee concluded with a program of state and national importance. In the late afternoon, veterans and spectators returned to Manassas from the battlefield. They assembled in front of the Prince William County Courthouse to hear an address by President William Howard Taft. While Taft spoke for just a short time about the importance of world peace, the speech reportedly brought tears to the eyes of the already emotional crowd. Visiting and local dignitaries shared the stage with President Taft, including Virginia Governor William Hodges Mann. Mann, standing next to Taft, was the last governor of Virginia to serve in the Civil War. The Jubilee wound down that evening with receptions at the Thornton and Portner homes. For the veterans of the battle and certainly for the citizens of Manassas, the Peace Jubilee was an event never to be forgotten.

Opposite, above: The Peace Jubilee reached its symbolic climax on the morning of July 21, 1911. Veterans and spectators assembled on Henry House Hill, where veterans filed into ranks of Union and Confederate. They then faced each other on the grounds where so many of their comrades had been killed or wounded and clasped hands in friendship and reconciliation. A "Love Feast of the Blues and Grays" prepared by local ladies followed.

Opposite, below: Symbolism played a large role in the Peace Jubilee. As a way of showing the unity of the United States, local girls, each representing a state, performed for the crowd. The Peace Maidens, dressed in white, sang the Jubilee Anthem "United," composed for the event by Mary Speed Mercer.

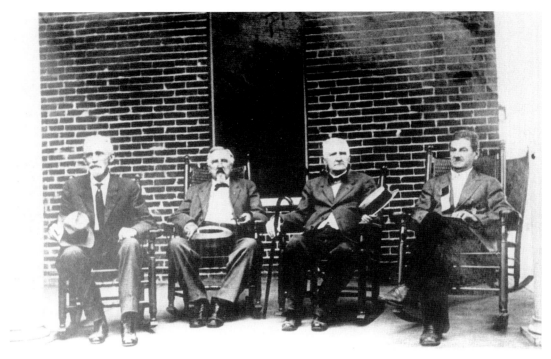

With much flair and little sympathy, John Singleton Mosby and his Rangers terrorized Union troops in Northern Virginia throughout the Civil War. They destroyed rail lines, captured supplies and horses, and even snatched a Union general from his bed one memorable night. Their exploits were famous nationwide. Soldiers as well as citizens knew of their cunning and bravado. These men seated on the porch of the Stonewall Jackson Hotel on July 20, 1914, hardly seem capable of such daring escapades. Seated from left to right are Fountain Beattie, Lycurgus Hutchison, John S. Mosby, and George Turberville. Beattie, Hutchison, and Turberville, like all of Mosby's Rangers, came from the Piedmont region. After the war, they settled back into their lives near Manassas. Mosby's postwar career included service as U.S. consul to Hong Kong, but he spent his last days in nearby Warrenton, Virginia.

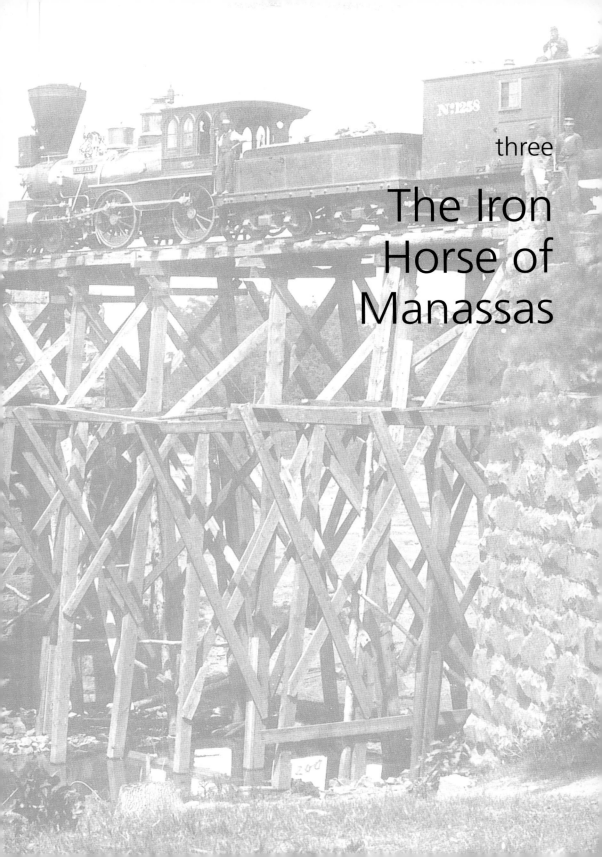

three

The Iron Horse of Manassas

ORANGE & ALEXANDRIA R. R.

Only Safe and Certain Line!

NO DETENTION FROM ICE!!

Omnibuses leave Washington City, at 6 o'clock, A. M., on the arrival of the Cars from *Baltimore*, to convey Passengers to *Alexandria*, where they can *Breakfast*, and take the Cars of the *Orange & Alexandria Rail-road*, and arrive at *Gordonsville* by 11 o'clock.

The Trains of the *Virginia Central Rail-road* connect at *Gordonsville*, and will convey Passengers to *Richmond*, *Charlottesville* and *Staunton*; reaching the former place by half-past 2 o'clock, in time to connect with all the Lines going South and West.

W. B. BROCKETT,
Agent.

December, 8th, 1854.

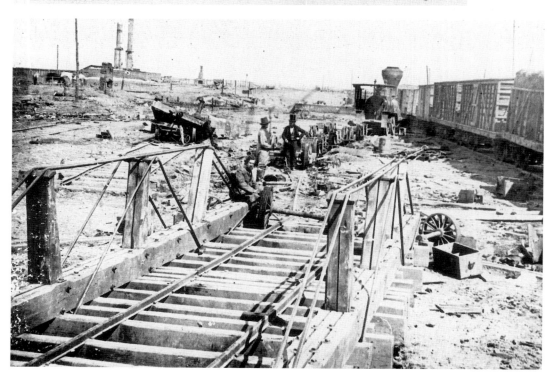

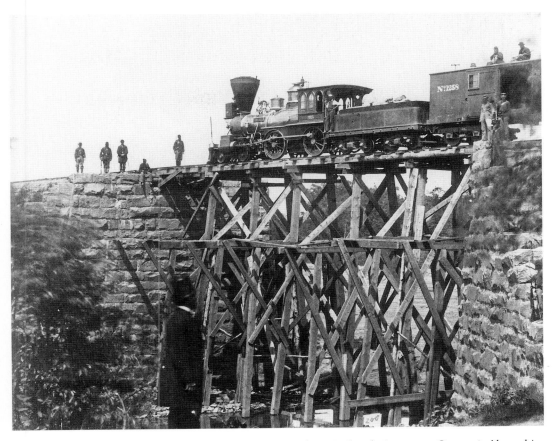

Above: The locomotive *Firefly*, of the United States Military Railroad, sits atop an Orange & Alexandria trestle at nearby Union Mills, Virginia. The Federal government, on January 31, 1862, established the United States Military Railroad to control the operations of captured Southern railroads. The Military Railroad had the authority to take possession of rolling stock and equipment and to use the lines to transport troops, arms, ammunition, and military supplies. Although the officers of the Military Railroad held military ranks, they were hired civilians. Therefore, men like the one pictured in the foreground did not wear uniforms; they wore civilian clothing instead. (Courtesy of the Library of Congress.)

Opposite, above: By the late 1840s, enterprising farmers and businessmen in Northern Virginia began organizing railroad companies to provide cheaper, faster alternatives to turnpikes for moving wheat to coastal markets. In October 1851, the Orange & Alexandria Railroad (named for the towns it connected) reached the Manassas area, then called Tudor Hall after a nearby farm. That same year, the Virginia General Assembly chartered the Manassas Gap Railroad Company to connect Tudor Hall with the Shenandoah Valley towns of Strasburg and Harrisonburg. Now farms as far west as the Blue Ridge Mountains could be linked by rail to Alexandria and Washington, D.C. Suddenly, prospects for prosperity were taking a giant leap forward.

Opposite, below: The Civil War dashed all hopes of prosperity brought to Manassas by the railroad. Confederate troops improved Manassas Junction by building a turntable to help with the movement of trains. A few months later, however, they destroyed what they and their civilian predecessors had built. This photograph documents the wrecked turntable and railroad debris in March 1862, when the Confederates evacuated the Junction. (Courtesy of MOLLUS/USAMHI.)

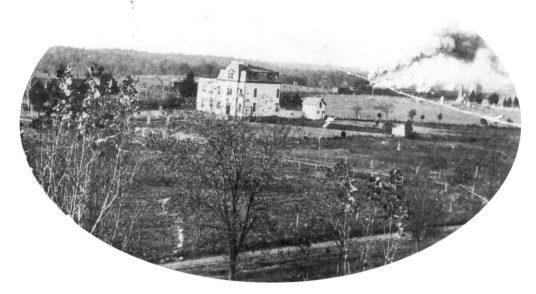

Oh what a beautiful day! In 1900, life in Manassas was chugging forward, as were trains through the countryside. After the Civil War, the railroad, spurred on by capital from Northern investors, again began to travel through the Piedmont and Manassas. By the turn of the twentieth century, the railroads were running full force. Steam engines, billowing smoke, traveled frequently past Ruffner School and the growing town of Manassas.

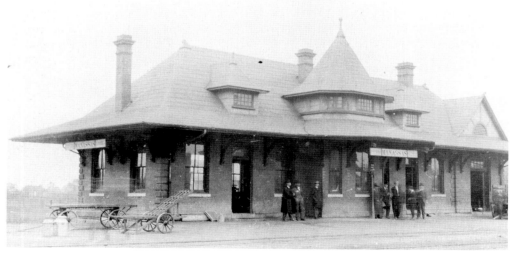

In Manassas, at the turn of the twentieth century, the Railroad Depot was one of the most important places in town. At the depot people caught trains, received telegrams, and picked up freight. Manassas has had five depots throughout its history, three on the current depot site. This building, constructed by the Southern Railway in 1904, was the fourth depot in Manassas. It burned in 1912.

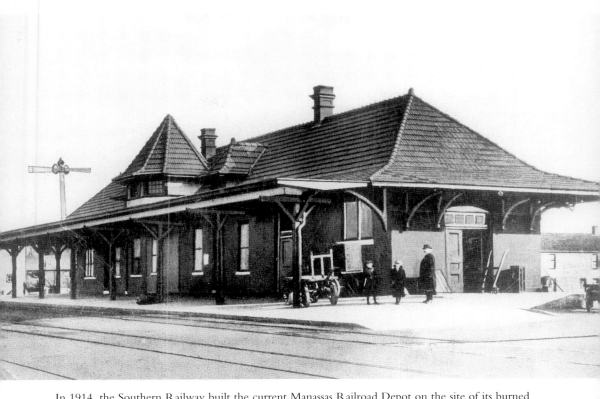

In 1914, the Southern Railway built the current Manassas Railroad Depot on the site of its burned predecessor. Made of brick with a clay tile roof, the depot has survived more than 80 years. As originally constructed, it featured four main rooms—a "white" waiting room, a "colored" waiting room, a ticket office, and a baggage room. This room configuration resulted from national laws for public buildings that dictated a policy of separate but equal. Today the rooms are used very differently. The City of Manassas owns the depot, and it is part of The Manassas Museum System. It houses the Manassas Visitors Center, a railroad heritage exhibit gallery, and a single waiting room for all passengers. The depot is also home to Historic Manassas, Inc., a National Main Street organization that promotes revitalization of the city's Old Town district.

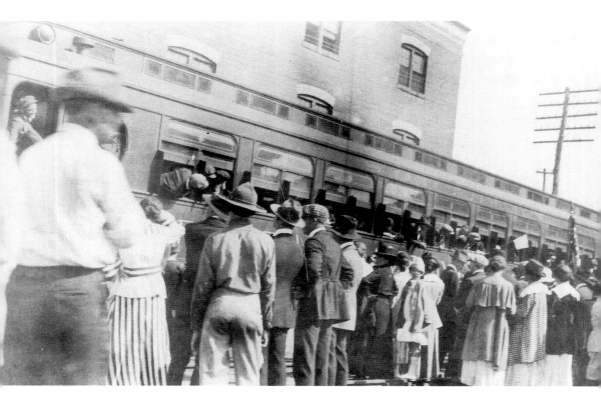

Persons alive when troop trains carried loads of soldiers in and out of Manassas during the Civil War must have been flooded with memories as trains again carried soldiers off to World War I. Although the Great War raged on a distant continent, the harsh realities of battle once more affected Manassas. Many of Manassas' young men went off to fight in Europe on the troop trains traveling through town.

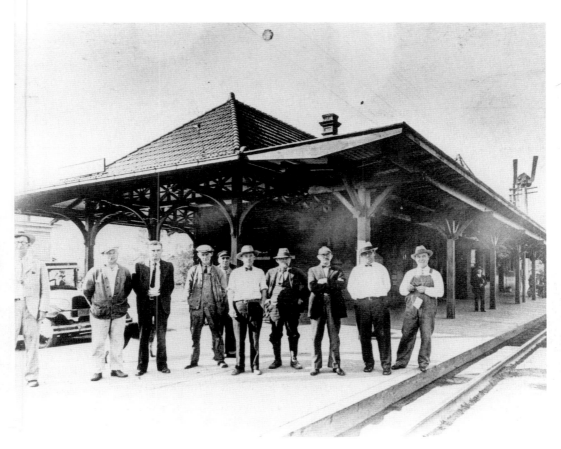

Naturally, the railroad employed many residents of Manassas. Local men worked as engineers and firemen, laborers on the rails and in the station, telegraphers, freight agents, mailmen, and crossing guards. Also, enterprising young people earned spending money by helping out around the trains. Some of the men who worked for the Southern Railway in the 1920s posed for this picture next to the depot. From left to right are Oscar Hudson, telegraph operator; John Maloney, mail handler; Achilles Wilson, relief operator; Thomas W. Howard, car repair foreman; Bernard Trimmer, car repairer helper; J. Raymond McCuen, freight agent; Watt Merchant, commercial drayman; G. Walker Merchant, telegraph operator; Claude Hixson, ticket clerk; and Rixey Embrey, baggage and express clerk.

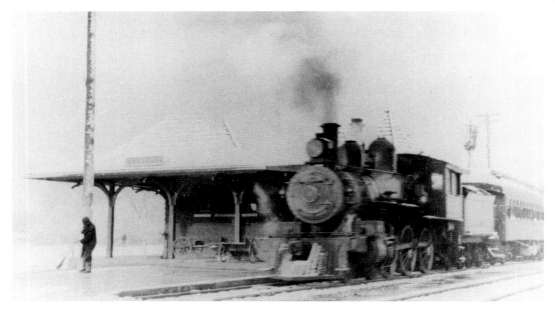

The 1920s saw the heyday of passenger travel through Manassas. Passenger trains, like this one of the Southern Railway, stopped in Manassas regularly. At that time, about 15 passenger trains of the Southern Railway and Chesapeake & Ohio Railway made regular or flag stops at Manassas in either direction daily. This frequent schedule made it possible for Manassas residents to commute to work in Washington, D.C., while maintaining a quiet life in the country.

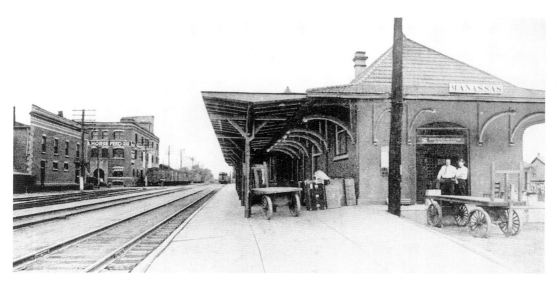

By the time this photograph was taken in the 1930s, railroad tracks had run through Manassas since the 1850s. Although the tracks have stood in the same place for more than 100 years, the owners of the trains running over them have changed many times. Some of the owners include the Orange & Alexandria; Manassas Gap; Orange, Alexandria & Manassas; Virginia and North Carolina; Washington City, Virginia Midland, and Great Southern; Virginia Midland; Southern Railway Company; and Norfolk Southern Corporation.

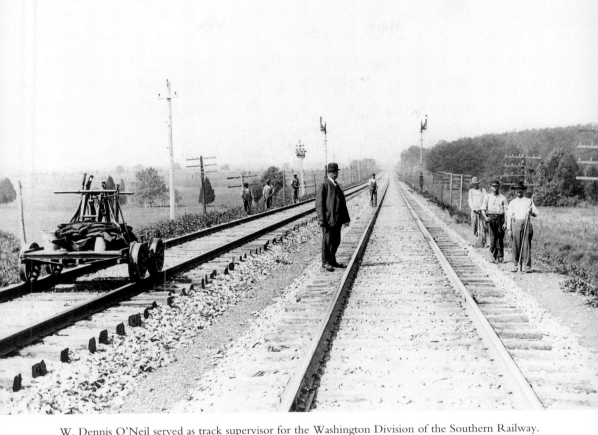

W. Dennis O'Neil served as track supervisor for the Washington Division of the Southern Railway. O'Neil is seen here near Nokesville at the beginning of the twentieth century overseeing one of the work crews that maintained the railroad tracks. An enormous amount of track crisscrosses the American countryside. For years laborers toiled, laying track over varied terrain and through what seemed to be immovable physical barriers. Laying the track, however, was just the beginning. Track maintenance was a never-ending part of running a railroad. Railroad employees inspected every inch of track and kept it in working order so trains ran safely and on time. When something or someone damaged the tracks, a crew of workers, like the one seen here, had to immediately make repairs so that the trains could again reach their destinations.

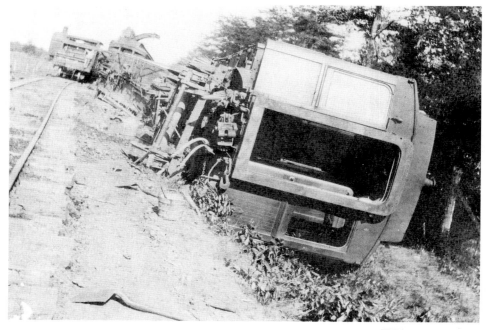

All it took was a faulty track for a train derailment to occur. Although not an everyday occurrence, train accidents and derailments were frequent at the beginning of the twentieth century. This horrible train accident happened right outside Manassas, near the Wellington crossing, in June 1905.

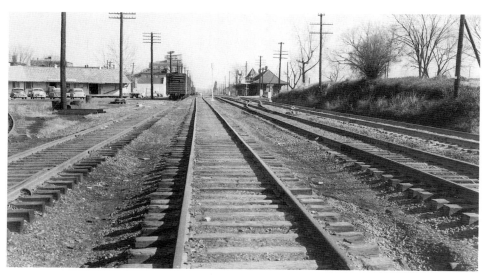

The railroad was vital to Manassas, but it was also dangerous for citizens trying to cross the tracks. In town, five streets crossed the railroad—Grant, West, Battle, Main, and Fairview. On December 22, 1923, at the Grant Avenue crossing, four young men died when an oncoming train hit their car. As a result, the town decided to install a watchman at each crossing. This photograph from 1955 looks east from the deadly crossing.

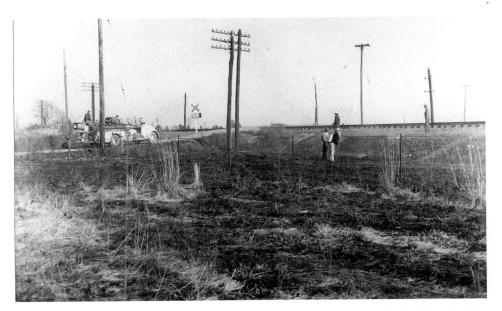

The railroad caused many exciting and dangerous happenings. For instance, the firefighters in this 1950s view are putting out a brush fire burning beside the tracks. Even in the 1950s, many railroad crossings still did not have safety devices. The Town of Manassas installed electric bells and automatic devices at its five crossings in 1945, replacing the watchmen, who formerly kept the crossings safe for traffic.

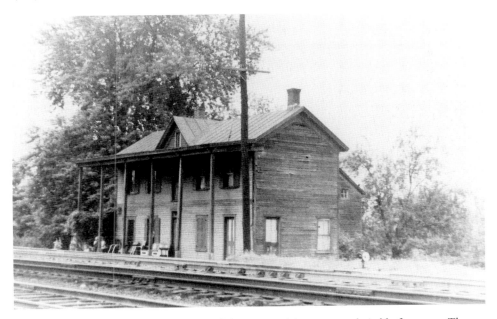

A house along the railroad tracks in turn–of–the–century Manassas was desirable for many. The railroad brought people, goods, and news to town. For some, living by the railroad meant living near their job. Several railroad postal clerks constructed homes on Prescott Avenue along the tracks. This house, photographed in the 1950s, stood near the depot and the Main Street crossing.

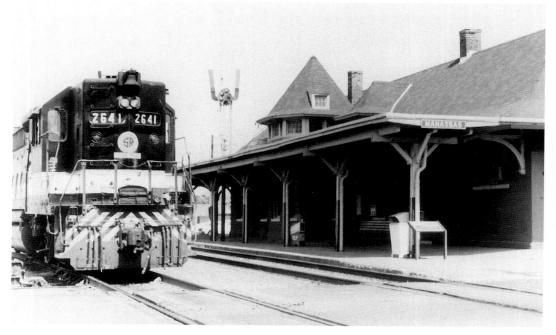

Transportation in the twentieth century changed greatly. Diesel locomotives, like this Southern Railway engine passing the depot in the 1970s, replaced steam locomotives. At the same time, automobiles, tractor-trailers, and airplanes began to do much of the work of trains. Despite these changes, the railroad has endured in Manassas. Though Manassas reached a low point right after WW II when rail traffic fell off significantly, the 1990s have seen a resurgence of rail usage. Increased freight hauling and renewed passenger service through Amtrak and the Virginia Railway Express have assured the railroad's place in the life of Manassas into the next millennium.

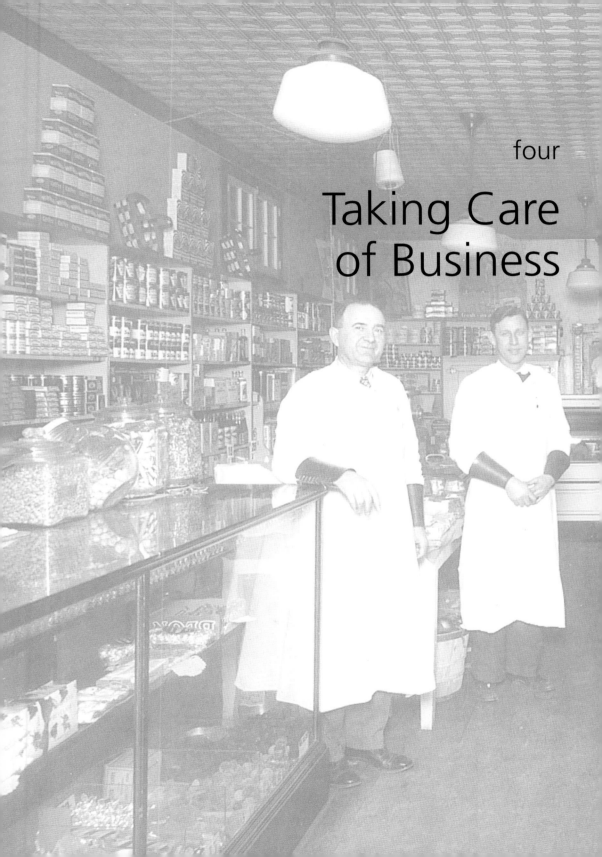

four

Taking Care
of Business

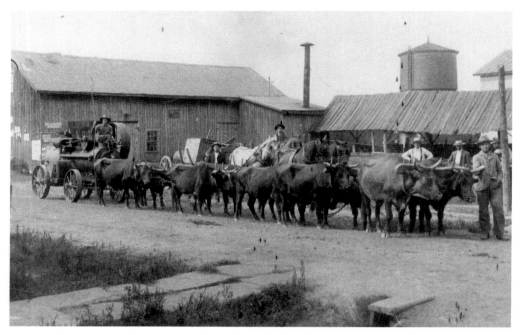

One word comes to mind when looking at a picture of Morey's Saw Mill with a large team of oxen in front of it—rural. In 1895, when this photograph was taken, big business in Manassas meant farming or milling. The sawmill, important in any small town for lumber, stood in Manassas at the southwest corner of Center and West Streets. Morey's provided lumber that was used in the churches, houses, barns, sheds, warehouses, stores, schools, and other buildings that residents were erecting in the town and the county. Oxen, as seen here, were still common on Manassas' dirt roads into the early twentieth century. In fact, residents of Manassas regularly encountered animals running free in their town in the late nineteenth century. Not until July 1900, when the town passed an ordinance prohibiting animals from roaming freely, did the streets of Manassas become completely clear of the nuisance and danger of animals.

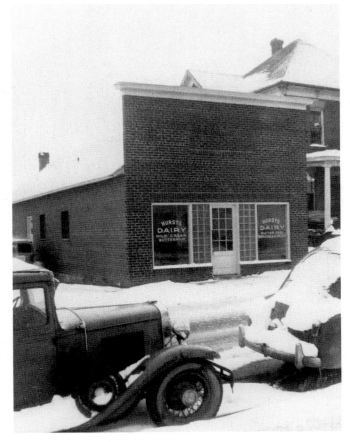

Right: The Hurst processing plant in Manassas, seen here in 1945, was just one of many around town. The Hurst family began dairying in the Nokesville area and moved to Manassas in the 1930s. The windows read, "Milk, Cream, Buttermilk," which were all produced by the Hursts.

Opposite, below: Milk is good for the body, and it was good for Manassas. By the end of the nineteenth century, dairy farming had taken a strong hold in Manassas. Dairy farms, like "Birmingham," owned by J. Carl Kincheloe, produced milk and other dairy products for distribution all over the Northern Virginia and Washington, D.C., area.

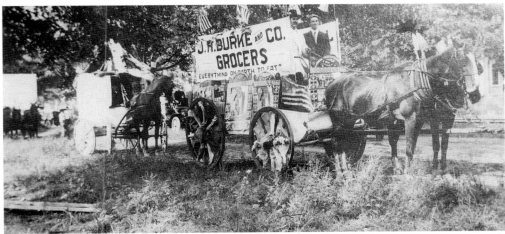

"Everything on Earth to Eat," read the banner on J.R. Burke Grocers and Company's wagon. Burke, a grocer in Manassas, decorated a wagon advertising his store and joined in an early-twentieth-century parade. While he may not have had everything on Earth to eat, Burke was just one of several grocers in Manassas giving citizens quite a selection.

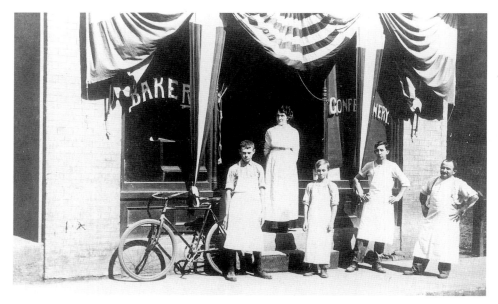

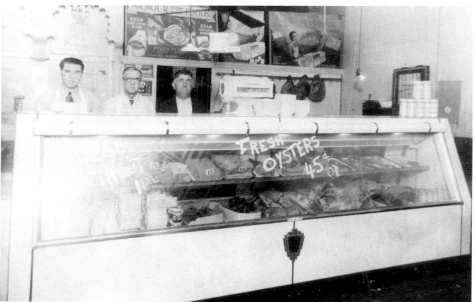

Who could sell tender steaks at 2 pounds for a quarter, roasts for only 8¢ a pound, and stew meat at 4¢ a pound? In the early twentieth century, Conner's Meat Market could. In business for over 40 years on Center Street, the market owned and operated by E.R. Conner supplied Manassas with meat and seafood. When the shop first opened, most customers selected their cuts of meat on Friday or Saturday and asked Conner to keep it in his refrigerator until Sunday morning. In 1934, E.R. Conner, on the right, posed behind the meat market's counter with his employees Wilson Kite, left, and T. J. Broaddus, center.

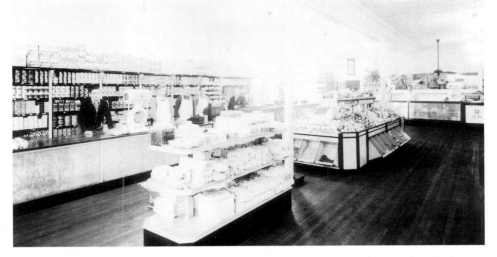

Above: In Manassas, the name Bushong meant groceries. From 1915 to 1942, Joseph L. Bushong operated a thriving grocery store. Fully stocked and well maintained, Bushong's store offered residents a wide variety of food and friendly service. Bushong moved his store three times. This photograph shows the second store, opened in 1927 at Main and Center Streets.

Opposite above: Cookies, cakes, pies, breads, and confections whipped up at Bell's Bakery could make any mouth water. Standing in front of the bakery in 1911 are, from left to right, Irvin Dodd, Kate Randall, Floyd Bryant, Keirl Bryant, and Jesse Bell. Between Bell's Bakery and Smith's Bakery, Manassas residents did not have to go far for bread and sweets.

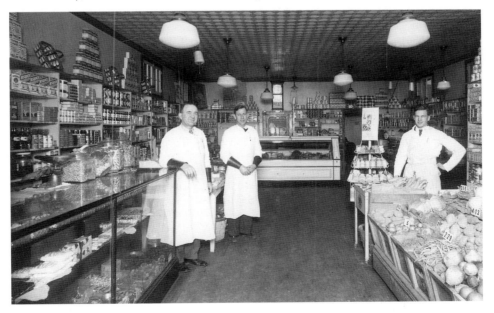

Opening day, May 1, 1932, of the third Bushong store shows the new establishment looking as neat and inviting as its predecessor did. Joseph Bushong, at left, stands proudly in his new store along with son-in-law Sedrick Saunders, in the center, and John Waters on the right.

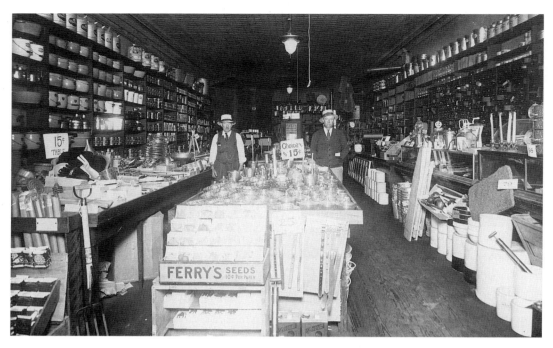

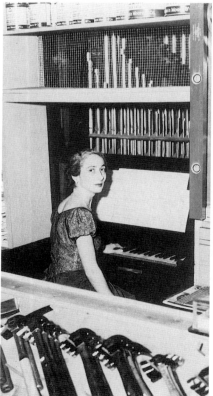

Above: C.E. Fisher and Son Hardware, located on Battle Street, offered patrons just about anything they could need, from buckets and pitchforks to leather belts and sleds. Standing in the middle of the teeming shelves in 1935 are Charles E. Fisher on the left and his son, Charles Cleveland Fisher, on the right.

Left: A pipe organ in a hardware store? In between the hammers and the paint, this unusual sight greeted visitors to C.E. Fisher and Son Hardware. The Fishers held several concerts over the years. Here, Helen Williams gives a recital at the hardware store in 1958.

Opposite, above: The overflowing shelves of unique items and the candy sold by the pound at Rohr's 5¢ to $1 store amused and thrilled Manassas residents both young and old. Started in 1934 by 18-year-old Edgar Rohr, the variety store, seen here in 1948, prospered for over 60 years. Adjacent to the store, Rohr and his wife, Walser, also ran a museum filled with their personal collection of antiques and vintage cars.

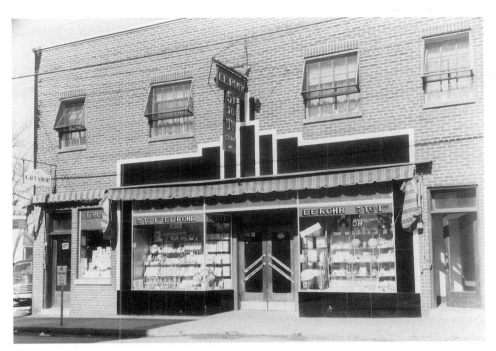

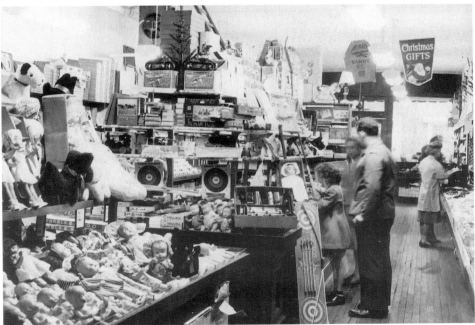

Above: "If you want something at the store and don't see it, just ask. We probably have it, and if we don't, we will try to get it for you." That was Edgar Rohr's motto and follow it he did. Every day Rohr's Store was stocked with goods from floor to ceiling. It carried a wide variety of products, and there was no telling what treasures an adventurous shopper might find hidden away on the shelves.

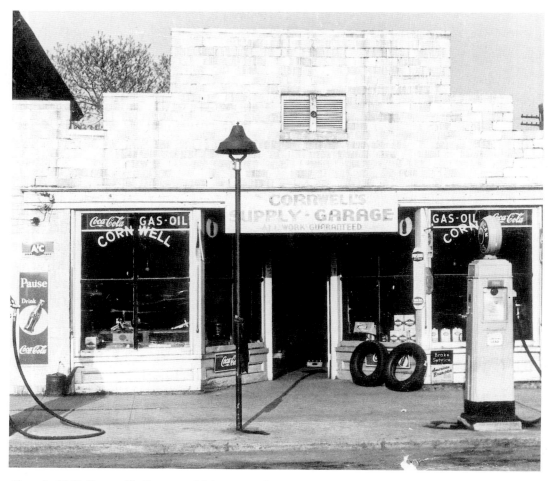

Above: In 1947, Cornwell's Garage on Main Street offered gas and garage service, housed the Manassas Taxi Service, and carried a wide assortment of farming machinery and implements. The presence of this garage and others like it in Manassas reflected the move in the early twentieth century away from horses and trains to the automobile. The transition from horse to car was not an easy one for Manassas. In the early days of automobiles, those with cars were expected to fend for themselves on the dirt roads and often were told to "Get a horse!" Eventually, more automobiles came to Manassas forcing the Town to pave the roads and create laws to control traffic. In 1921, the Town Code stated that no one could drive faster than 12 miles an hour, no children under 14 could operate an automobile, and all traffic on Center and Main Streets had the right-of-way over all intersecting streets.

Opposite, above: The Manassas Service Station, seen here in the early twentieth century, met the growing needs of motorists in Manassas. By the 1940s, W. Caton Merchant owned the station. Early in his career, Merchant recognized a growing market in automobile tires, and in 1942, he began selling them. Starting with an inventory of six tires, he built the Merchant's Tire and Auto Service Corporation, with locations throughout the eastern United States.

Opposite, below: Many residents of Manassas dreamed about owning a brand-new car, and Prince William Motors on Center Street was just the place to find one. The 1949 showroom displayed the shiniest new cars Ford had to offer, just waiting to be driven off by a lucky Manassas motorist.

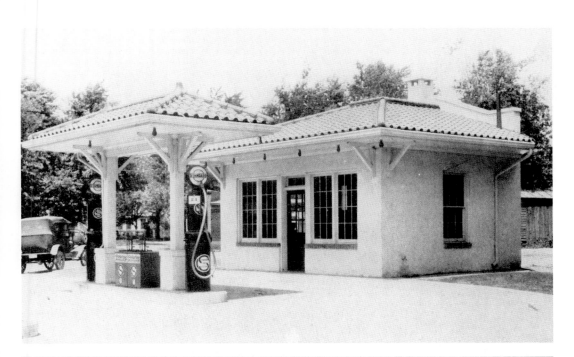

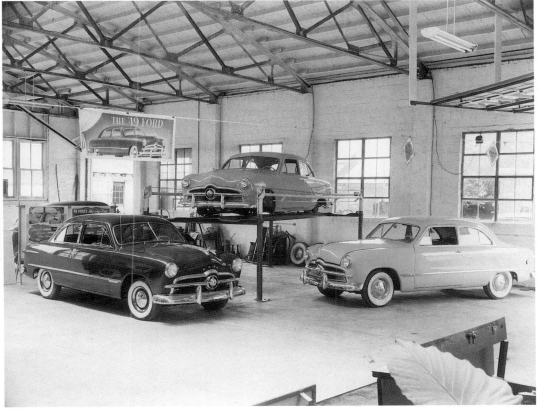

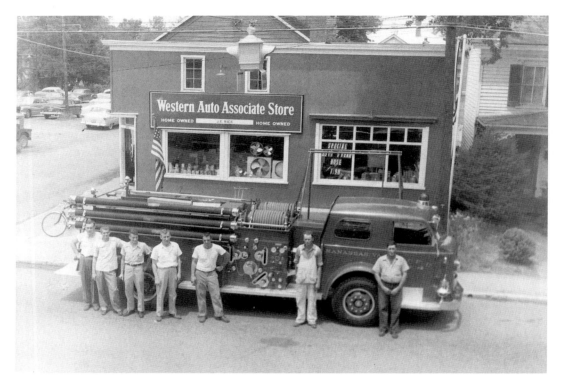

Repairing cars required parts and tools. J.E. Rice recognized that need and opened his Western Auto Associate Store on the corner of East and Center Streets in 1936. The store, seen here in 1954, sold hardware and appliances in addition to automotive supplies. In 1957, J.E. Rice opened a second store in the Manassas Shopping Center. The original store closed, but the second store continues in business today.

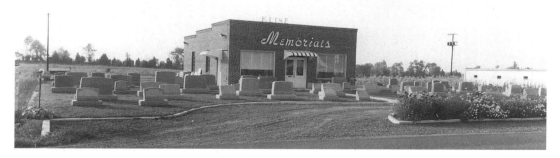

Another business owned by a local family that has served Manassas residents for several generations is Kline Memorials. Begun in 1901, Kline Memorials originally stood on West Street. In 1952, they moved, like many businesses at that time, out of the downtown area to Centreville Road, where they continue to provide Manassas residents with tombstones and other memorials.

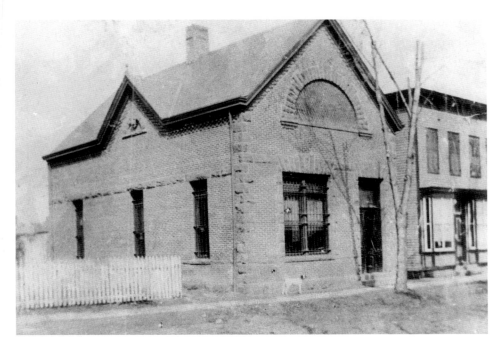

The first banking establishment in Manassas, the Manassas National Bank, began in this small brick building on Main Street. Built as a bank in 1896, the structure served that function only a short time. In 1912, the Manassas National Bank moved, and since then, this building has undergone a series of uses, including serving as the home of The Manassas Museum from 1974 until 1990.

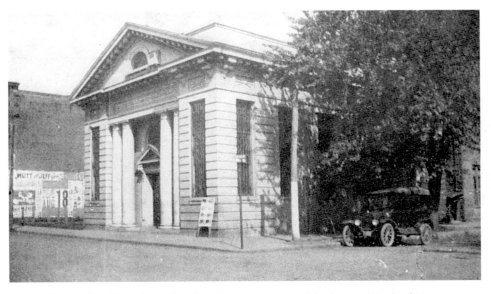

Designed by local architect Albert Speiden, the second home of the National Bank of Manassas was a grand building. Located on the corner of Center and Main Streets, next to the original bank, this 1912 building housed the National Bank and its successor, the First Virginia Bank, until 1997.

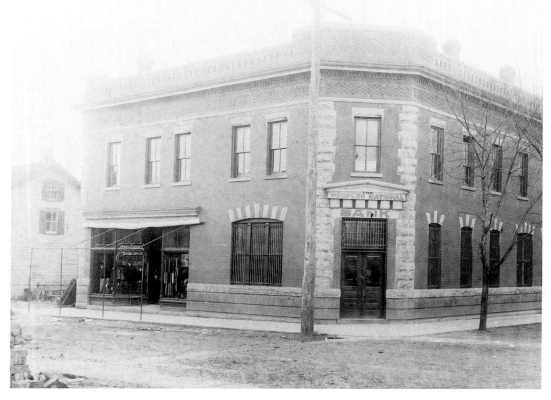

In 1903, a second bank came to town, the Peoples Bank of Manassas. The bank needed a home, and in 1904, its directors had this impressive building constructed on the northwest corner of Center and Battle Streets. Shortly after its opening, the building almost met its end, when the devastating fire of 1905 burned through the Manassas business district. Local lore says that Manassas resident Donation Libeau saved the building from destruction when he extinguished the burning cornice by pouring water on it from an upstairs window. In 1956 the Peoples Bank moved into a new building at the corner of Battle and Church Streets.

Right: Around 1895, Ira Cannon, John Burke, and Will Clark started the Manassas Telephone Company and brought modern communication to Manassas. It began small but expanded steadily. As the telephone grew in popularity, rules and regulations developed. One rule early in the twentieth century was as follows: "Anyone through curiosity listening to conversations over the line, is respectfully requested to keep the battery cut off, otherwise those using the line will be disturbed."

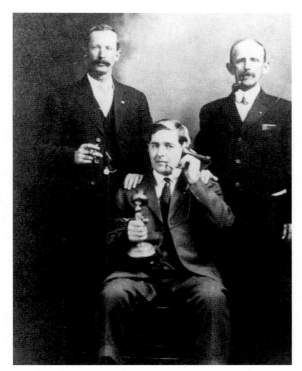

Below: The telephone operator, often the most knowledgeable person in town, connected Manassas to the rest of the world. Esther J. Bell Randall served as operator for the Manassas Telephone Company in 1904. She worked on a second-floor room over Bell's Store near the corner of Center and West Streets.

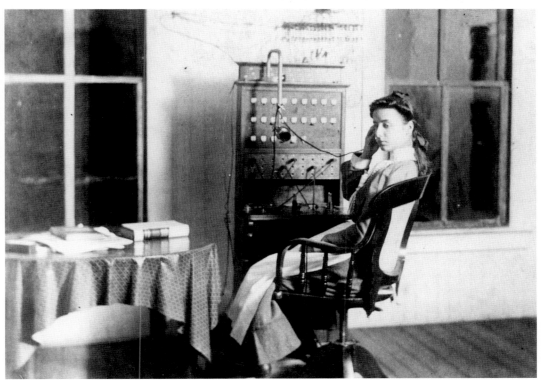

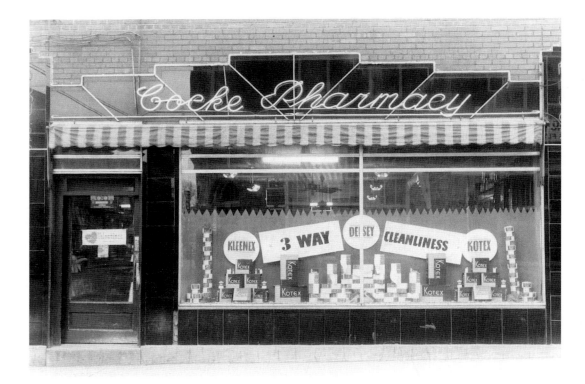

Above: Cocke's Pharmacy on Center Street, seen here in 1950, operated under the motto "Where Friends Meet," and undoubtedly, this was true for many in Manassas. Young people, for almost four decades, considered Cocke's the place to be and be seen. Dr. George B. Cocke opened the beloved pharmacy in 1919 and ran it until 1957. Although Cocke's was a drugstore, people flocked there more for its homemade ice cream and made-to-order sodas. Initially, the pharmacy had just a soda fountain and a few tables. As a result, at busy times such as when school let out, customers would stand five deep waiting for their turn at the soda fountain. The installation of a lunch counter in 1951 added to Cocke's draw, and it was busier than ever, serving sandwiches and drinks. The pharmacy stayed in the family until it was shut down in the 1980s. The closing of Cocke's marked the end of a Manassas tradition for longtime residents.

Opposite, above: While Cocke's Pharmacy seemed to have a corner on the market, several others, like the Prince William Pharmacy, conducted business in Manassas. In the early twentieth century, Dr. C.R.C. Johnson (right), owner of the pharmacy, posed in front of his store with Walter Akers on the left and Maurice Hopkins, third from the left. Interestingly, for a short while Dr. Cocke owned the Prince William Pharmacy, which was located on Center Street across from his original store.

Opposite, below: Before McDonald's and Burger King, Manassas had Wieneke's Snack Bar. The Wieneke family, who owned the Center Street business, could probably claim to have brought fast food to Manassas. The Snack Bar did not offer indoor seating. In the 1950s customers ordered their ice cream, hamburgers with secret sauce, and hot dogs through the window and ate them outside.

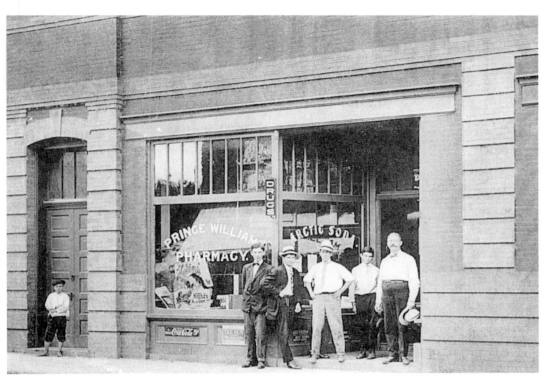

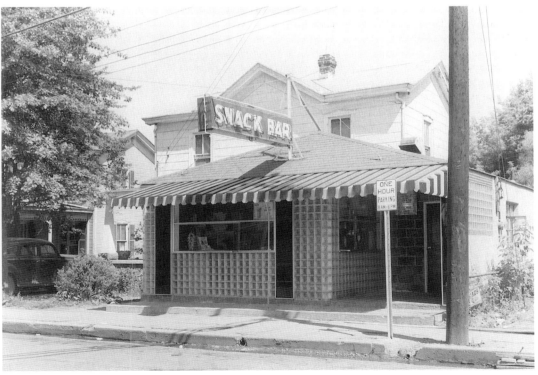

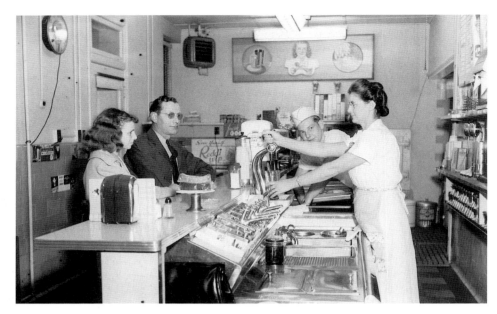

A night out for teenagers in the 1950s might include a stop at the Birmingham Milk Bar on Centreville Road. Like Cocke's during the day, the Milk Bar provided young people with a place to grab a bite to eat in the evening. Dinner fare included hamburgers and sandwiches, and dessert was often ice cream. The Milk Bar opened in 1949, and this photograph shows it on its first anniversary in 1950.

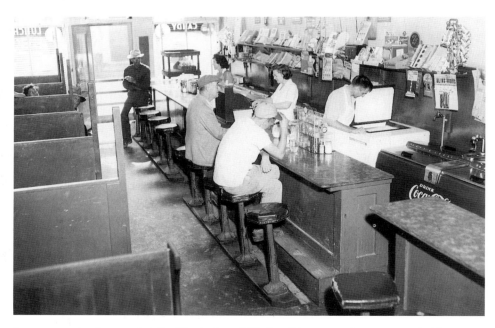

Ice cream and sodas served at the Birmingham Milk Bar did not appeal to everyone in Manassas. A different clientele frequented establishments like the Dixie Lunch on Battle Street. In the 1950s, these customers came in search of a quick meal and a cold beer.

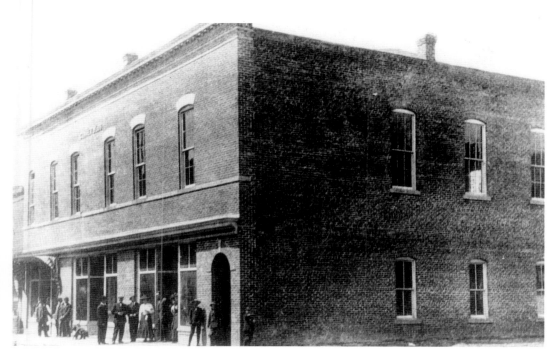

Above: E.R. Conner entertained Manassas with shows and movies he brought to the Conner Opera House on Center Street. Opened in 1906, the Opera House featured the first electric lighting in Manassas. Initially a venue for traveling shows, the Opera House later served as a hall for dances and meetings. Its first event was a reunion of local legend Colonel John S. Mosby and his Rangers.

Right: The Dixie Moving Picture Theatre, Manassas' first movie house, provided residents with a small but much welcomed addition to the town's entertainment options. Situated in a very narrow building on Main Street, the theater accommodated only four people on either side of the center aisle. Local piano player Mrs. William Compton, her daughter Eloise Compton Trimmer Branch, or a Victrola provided the music.

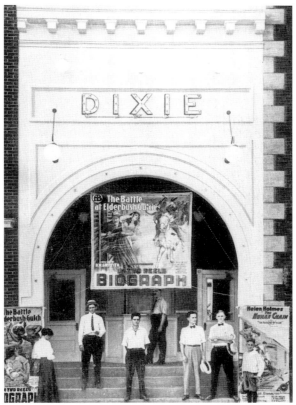

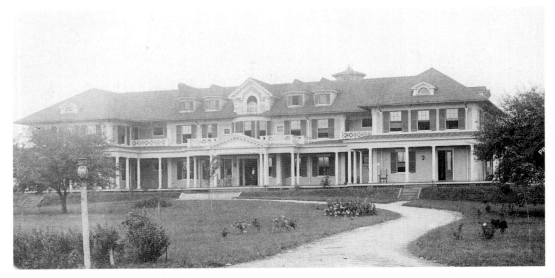

Above: For as long as there has been a Manassas, there has been at least one hotel in town. Even before the Civil War, when just a handful of buildings made up Manassas Junction, Belcher's Hotel housed travelers to the area. Immediately after the war, several hotels sprung up in Manassas—the Eureka Hotel, the Keyes House, the Cannon House, and the Goodwin House. The grandest of all was the first Prince William Hotel, seen here. Brewery baron and part-time Manassas resident Robert Portner built the 45-room luxury hotel in 1904, on the south side of the railroad between Grant Avenue and West Street. The hotel was well known for its opulent dining room. Sadly, it burned in 1910. Manassas has never again seen accommodations so grand.

Opposite, above: Two years after its namesake burned, a second Prince William Hotel opened its doors. Unlike its predecessor, the 1912 building on the corner of Main and Center Streets was a more traditional, square structure. By the late 1910s it operated as the Stonewall Jackson Hotel. The Stonewall Jackson, pictured here in 1954, was a popular meeting place for local groups such as the Kiwanis, and the coffee shop did good business. In the 1960s, developers razed the Stonewall Jackson.

Opposite, below: Since the 1960s, the Olde Towne Inn Motor Lodge has occupied the corner of Center and Main Streets. Its predecessor, the short-lived Downtowner, immediately replaced the Stonewall Jackson Hotel. Shunning all ties to the past, the architecture of the Downtowner/Olde Towne Inn building reflects the move in the 1960s to a completely modern facility geared toward the automobile traveler.

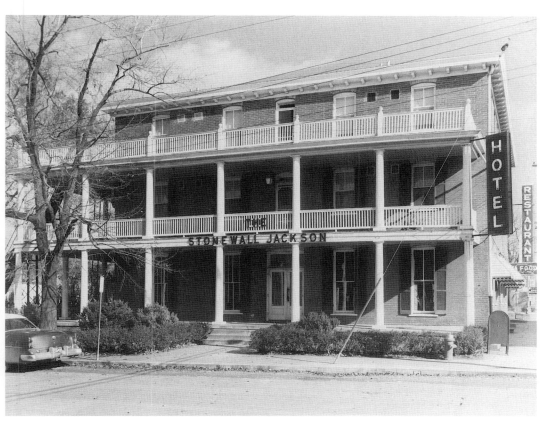

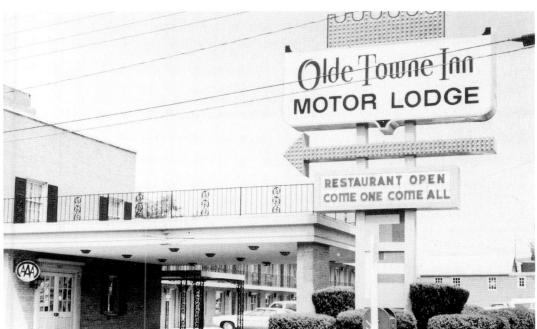

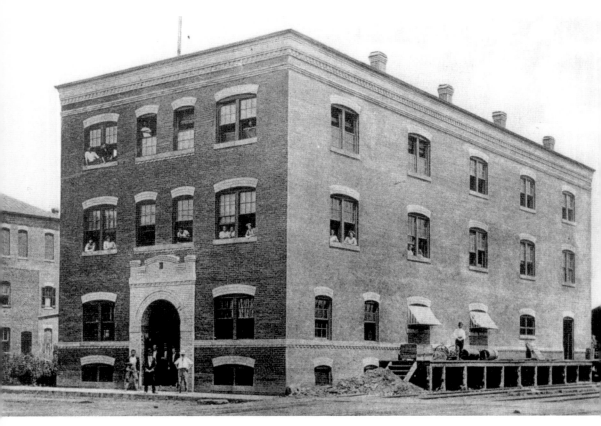

Above: A child's dream come true right in Manassas—a candy factory! The Hopkins Company added a new and tasty industry to Manassas. Founded c. 1900, the company employed more than 25 local citizens. Company salesmen covered expansive territories selling to wholesale houses. Early in 1908, the Hopkins Company erected a spacious brick factory on Battle Street, parallel to the railroad and adjoining the freight depot. The new three-story factory, designed by Albert Speiden, provided ample room for increased production and the convenience of unloading boxcars of ingredients at the factory's door. The Hopkins Company produced several lines of candies, including a hand-dipped chocolate variety. The Candy Factory did not last long; in 1916, Hopkins sold out to the Manassas Feed and Milling Company. The Candy Factory then went on to house a variety of different industries. Its last owners, Merchant's Tire and Auto, donated it to the City of Manassas in 1998. It is now part of The Manassas Museum System and will house a community arts center after renovation.

Opposite, above: Continuing the tradition of the Manassas Feed and Milling Company, Southern States Manassas Co-Op operated in the Candy Factory building on Battle Street. Considering the rural nature of Manassas, Southern States, which specializes in feed, seeds, fertilizer, and lawn and garden supplies, did a booming business. This 1950 photograph shows some of the modifications made to the Candy Factory after its construction.

Opposite, below: Whether to stay warm or keep cool, local residents have counted on Manassas Ice & Fuel Company (MIFCO) for more than 70 years. Started in 1922 by Edgar Parrish, MIFCO continues from its Center Street location to offer heating oil, motor oils, gas, and ice to Manassas and Prince William County. The Parrish family still owns and operates MIFCO, pictured here in 1951.

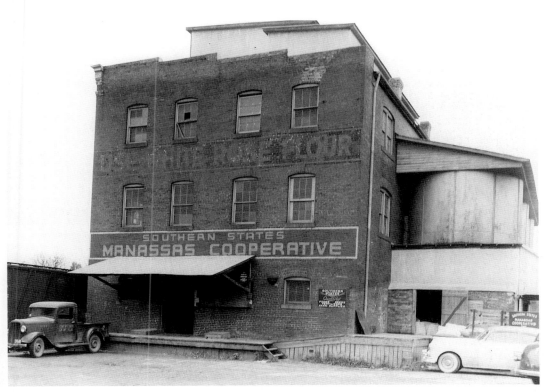

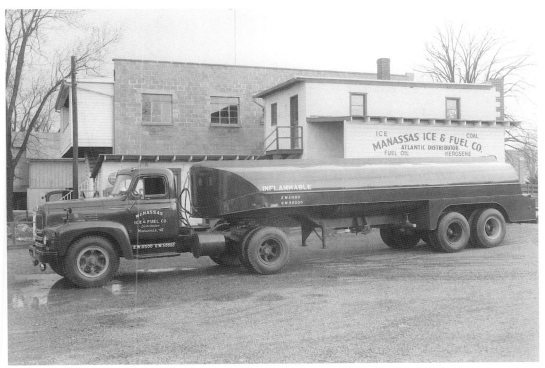

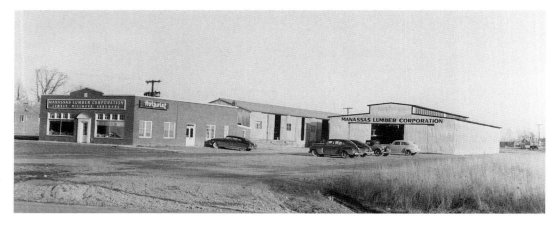

Manassas Lumber Corporation encouraged residents to make it their headquarters for building a brighter future. Located on Centreville Road, Manassas Lumber, seen here in 1949, opened its doors in 1947. Customers found everything in building materials, lumber, millwork, hardware, and paint that they could possibly need or want. Competition from national chain stores forced the Manassas Lumber Corporation to close in the mid-1990s.

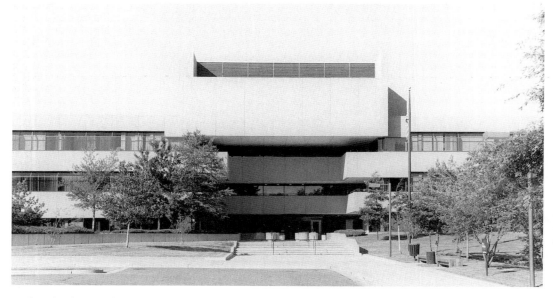

High technology is changing the world and Manassas. In 1969 International Business Machine (IBM) came to Manassas and opened a 1,000,000-square-foot manufacturing facility employing 3,000 people. Although IBM closed its original facility in the early 1990s, it paved the way for other high-tech corporations, such as Lockheed Martin and Dominion Semi-Conductor (an IBM/Toshiba partnership), each of which established manufacturing facilities in Manassas during the 1990s.

five

A Legacy of Learning

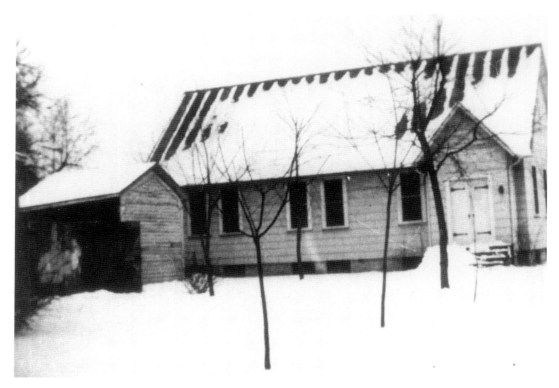

Above: Education is the cornerstone of society, and Manassas residents recognized this early on in the town's development. The progressive citizens of Manassas took aggressive steps toward establishing schools, public and private, white and black, for their children. Taking a leading role in the state and county, Manassas established the first public school for white children in Prince William County. In 1869, under the leadership of George Carr Round, Manassas set up the Manassas Village White School. Starting in December, class met in a room at the Asbury Methodist-Episcopal Church, seen here in the twentieth century. The newly established school board procured second-hand furniture and purchased textbooks from the Washington, D.C., School System. Miss Estelle Greene served as teacher for the first five and a half months' term. In the second year, the school rented the entire church, and George Bennett came on board as principal and head teacher. In November 1870, the school officially became part of the newly formed Prince William County School System. It continued to meet in the church until 1872.

Oppossite, above: Manassas can also claim the second public school in Prince William County, the Brown School. This school, however, educated African American students. From the beginning of public education in Virginia until the 1960s, students attended segregated schools. The original Brown School, pictured here in the twentieth century, still stands on Liberty Street in Manassas. Initially called the Manassas Village Colored School, it was founded in 1870 with Quaker funds given to the state. In 1928 the Brown School moved to a larger facility on Prince William Street that was built specifically for it. Students from around the county attended this school, which served as a feeder to the Manassas Industrial School for Colored Youth. In 1954, the County moved the school to the Regional High School building nearby, abandoning the Brown School building. In 1959, Prince William County built the Jennie Dean High and Elementary School, for grades 1–12. Students attended this segregated school until integration in 1966.

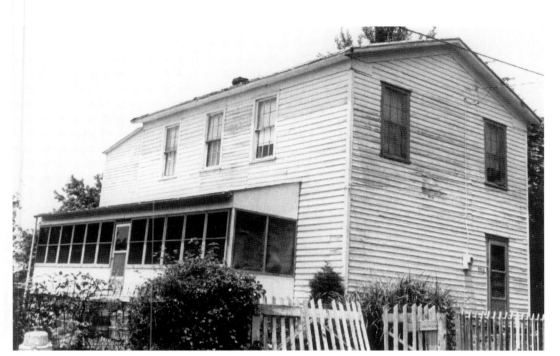

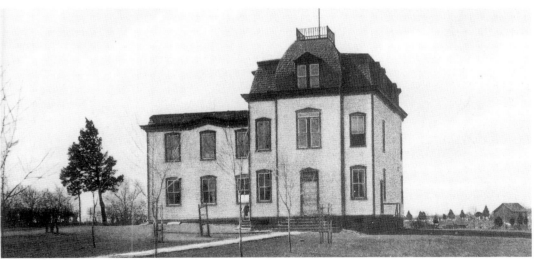

Above: Ruffner School Number One, named in honor of William Ruffner, the first state superintendent of schools in Virginia, opened its doors in 1872. This impressive two-story structure, designed by George Carr Round, provided a much-needed home for the Manassas Village White School. Located at Center and Peabody Streets, Ruffner was initially just an elementary school, but later it accommodated both elementary and secondary grades. As the population of the town and countryside grew, the building expanded as well. A welcome addition to the school was the library, built with funds donated by Andrew Carnegie. It opened in 1900 and became the first public library in Prince William County. By 1925, overcrowding became a problem at the Ruffner School-Manassas High School, and it risked losing its state accreditation. Therefore, the County closed Ruffner in 1927, and students attended the Bennett School and the Manassas High School. The Ruffner building was razed in 1930.

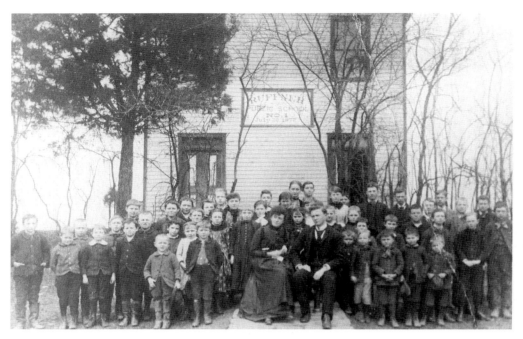

By 1890, when this group of students posed in front of the Ruffner School, enrollment had grown tremendously. When it opened, Ruffner housed 15 students and employed one teacher. In 1890, over 40 students attended Ruffner, and two teachers, Charles S. Scott and Maggie Foley, instructed the young minds of Manassas.

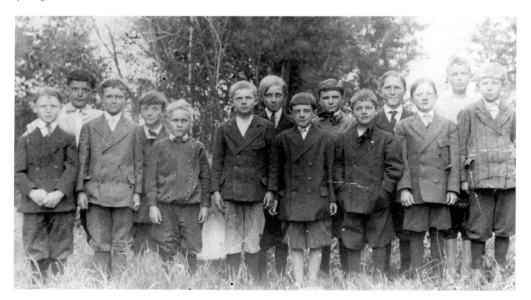

This dapper group of boys, many of whom later became civic and business leaders in Manassas, posed in the late nineteenth century for a group picture. From left to right are Edward Conner, Paul Williams, Herman Lunsford, Bruce Hynson, Paul Bryant, Ellis Cornwell, Floyd Bryant, Emmett Rice, Emmett Cather, Martin Rice, Herman Bryant, Gilbert Merchant, Thornton Cornwell, and Jack Lyon.

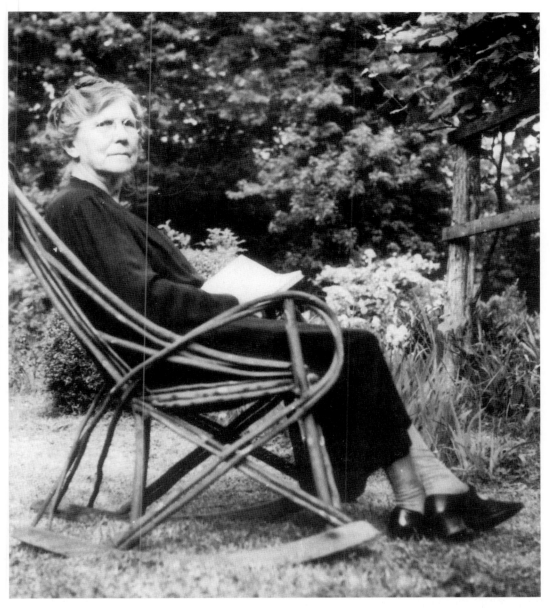

Eugenia Osbourn, seen here in 1945, and her sister, Fannie Osbourn Metz, educated most of Manassas' children for five decades, starting in the 1870s. Fannie Metz arrived first in Manassas and worked as a private teacher for families around the area. In 1890, Fannie sent for her sister Eugenia, and together they opened a private school, the Manassas Institute. The school taught grades one through twelve and provided the only secondary education in Manassas until 1906. That year the Institute merged with the public high school, and Fannie served as principal of the Manassas High School until her death in 1912. Eugenia followed as principal, retiring in 1935. After her retirement and before her death in 1951, the community honored Eugenia Osbourn by renaming the Manassas High School after her. By all accounts, both Eugenia and Fannie were extraordinary women and exceptional teachers. Their educational legacy endures in Manassas.

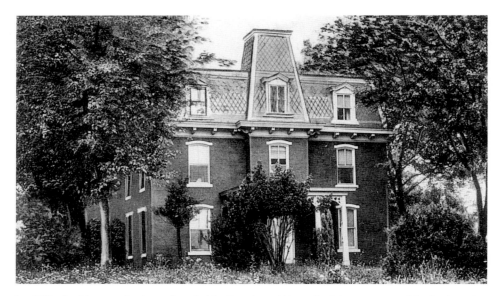

In 1890, the Manassas Institute, founded by Fannie and Eugenia Osbourn, opened for business in the Baldwin House, south of the railroad tracks. The Baldwin House, seen here in the 1910s, was the seat of every effort at private white education in Manassas. Built by Isaac Baldwin in the 1880s, the structure went on to house seven schools including the Manassas Institute, Eastern College, and Swavely School.

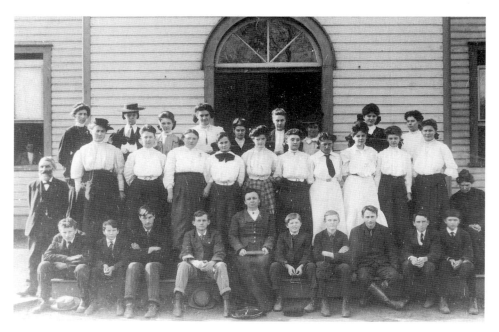

In 1906, the last class of the Manassas Institute, seen here in front of their Grant Avenue school building, graduated. In the fall of 1906, the Institute and the public high school merged, creating one school. Fannie Osbourn Metz and Eugenia Osbourn continued teaching the youth of Manassas at the newly formed Manassas High School.

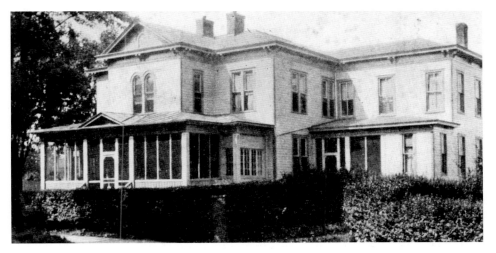

Like the Baldwin House before it, this building, known as the Temple School, saw use by multiple institutions. In 1896, the Osbourn sisters built the school to house the growing Manassas Institute. After the Institute vacated the building, it became the Temple School of Music, operated by Margaret Temple Hopkins. Still later the building served as a private elementary school. Today the building is a private residence.

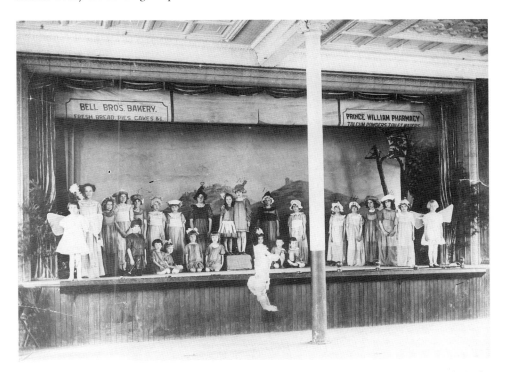

Naturally, the Temple School of Music showcased the talents of its students. On June 9, 1915, the school put on Cinderella in Flowerland at the Conner Opera House. This performance was just one of many that entertained proud parents and townspeople over the years.

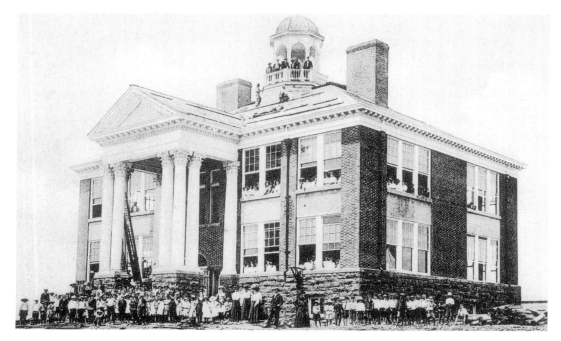

Above: In 1909, the students of the Bennett School joyfully posed for this picture marking the opening of their new building. Originally commissioned as Virginia's first Agricultural High School, the large, brick edifice on Lee Avenue, however, never saw a single high school student. Because the enormous grade school population in Manassas needed a home, Bennett opened as an elementary school and remained one throughout its educational career. The Ruffner School, which formerly housed elementary and secondary students, accommodated the Agricultural High School. Elementary students continued to attend this Bennett School until 1953, when Prince William County constructed a new Bennett building on Stonewall Road. The original Bennett School still stands and is used by Prince William County, but not as a school. A third Bennett Elementary School, built in the 1990s by Prince William County, stands on Old Dominion Drive.

Opposite, above: At the same time that the Bennett School served as the elementary school in the Town of Manassas, the Groveton School accommodated the children who lived just 5 miles north of it. Miss Grace Metz began her long teaching career at Groveton, staying for three years, from 1913 to 1916. Miss Metz and her Groveton students posed for this class photograph around Christmas 1915.

Opposite, below: Three years into her career, Grace Metz began teaching at the Bennett School. She took over the seventh grade and continued to teach until retiring in 1962. Like the Osbourn sisters before her, Miss Metz taught most of the children in Manassas. Her students, like these in 1952 at the Bennett School, remember her as a gifted educator and a kind lady.

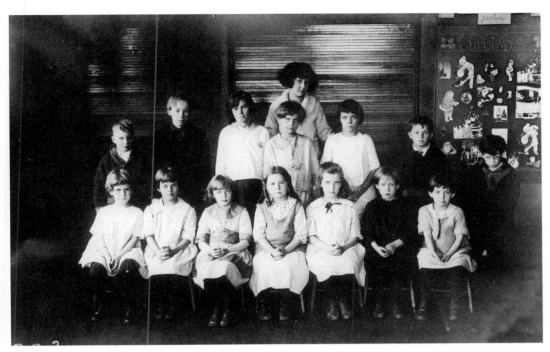

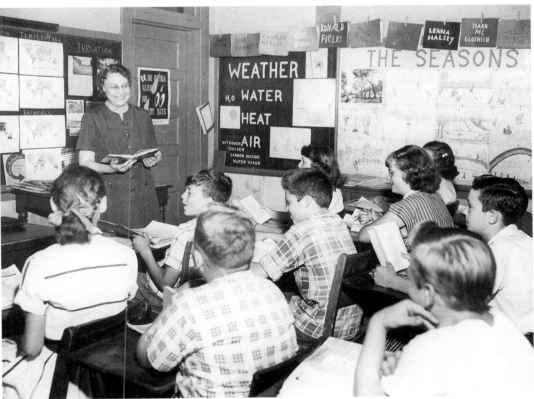

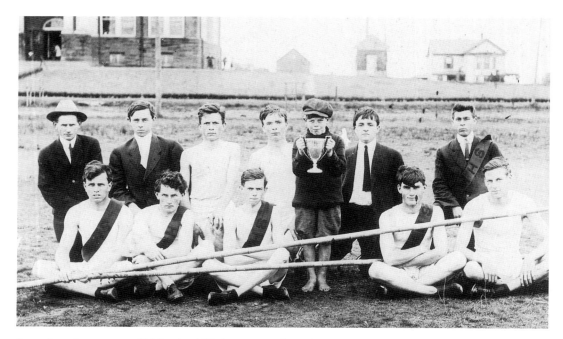

Sports have been a part of high school life in Manassas from the beginning. In 1912, just six years after the school opened, the Manassas High School track team achieved competitive success. Taylor Ware, in the center, holds a trophy marking the track team's victory. The team is pictured in front of the original Bennett School. At that time, the Ruffner building housed the Manassas High School.

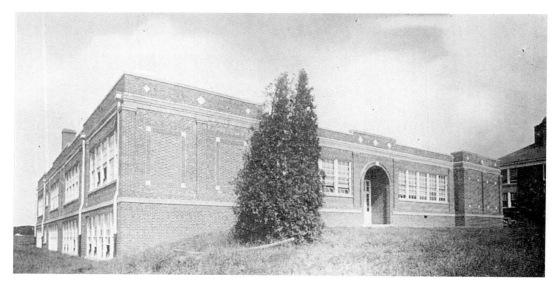

The construction of the Manassas High School in 1926, later called Osbourn High School, was a welcome relief to the already overcrowded Ruffner School. Finally, Manassas had a single building for secondary education. Built next door to the Bennett School, it housed students until 1953. At that time, a new Osbourn High School was built across the railroad tracks on Tudor Lane. The second Osbourn High School still stands but has undergone renovations and expansion with population growth.

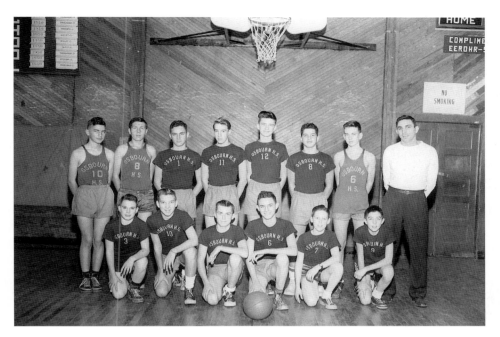

As in most small towns, high school sports in Manassas offered a great opportunity for community pride. High school basketball and football brought families and neighbors out to cheer their team to victory. The 1950 Osbourn High School boys' basketball team under coach James J. Leo carried on that sports tradition. (Courtesy of Ann Harrover Thomas.)

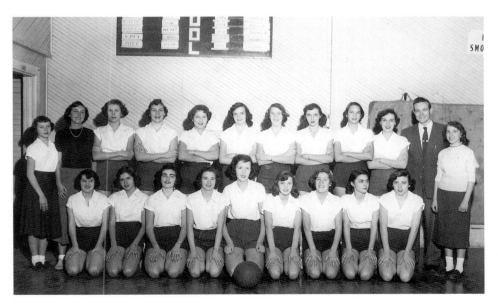

The girls' teams took their shot too. The 1952 girls' basketball team, like their male counterpart, made Manassas proud. Female sports have come a long way since the 1950s, and in the 1990s, Osbourn High School girls have more athletic opportunities than ever. (Courtesy of Ann Harrover Thomas.)

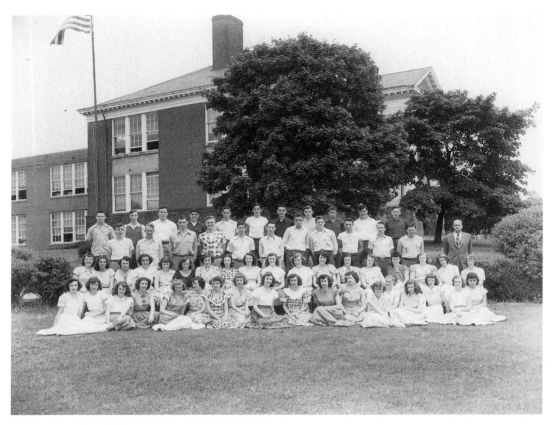

Above: Manassas, from its earliest days, has had an exceptional public education system. The well-educated students of Manassas, like the graduating class of 1950 seen here, can thank the devotion of the residents, teachers, and administrators in Manassas and Prince William County for all they have learned. As part of Prince William County, the Manassas School District took a lead in public education. Today, the city of Manassas continues that fine tradition in its seven schools—Baldwin, Dean, Haydon, Round, and Weems Elementary Schools, Metz Junior High School, and Osbourn High School.

Opposite: Born into slavery, Jane Serepta Dean, known as Jennie, never received a formal education. As a domestic working in Washington, D.C., and a missionary in Northern Virginia, Miss Dean became acutely aware that until African Americans received a proper education, they would always work in menial jobs. She decided to devote her life to improving the lives of her people through education. Traveling all over the Northeastern United States, Miss Dean raised money to build the Manassas Industrial School for Colored Youth. The school opened in 1894 and provided both academic and technical training for girls and boys. Guided by the motto "To Educate the Head, the Heart, and the Hand," Jennie Dean helped provide hundreds of students with the knowledge and training to improve their lives. Miss Dean died in 1913, having achieved her dream through her unflappable determination and devotion.

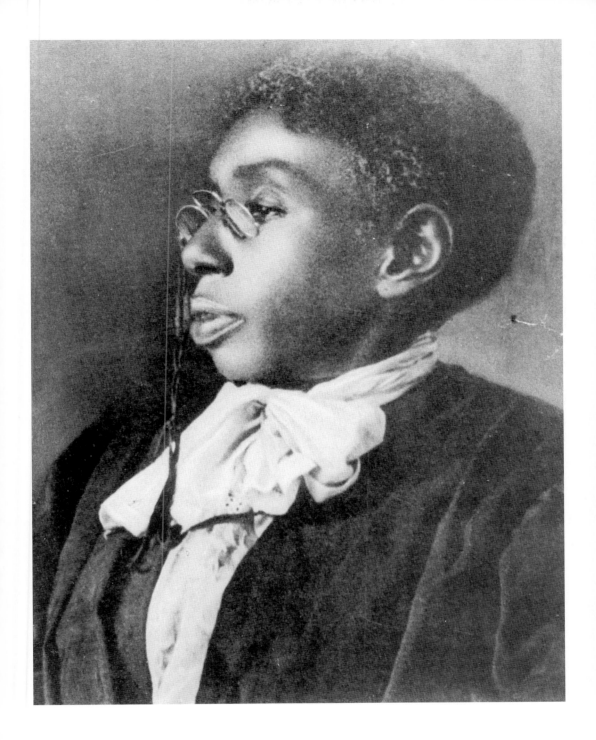

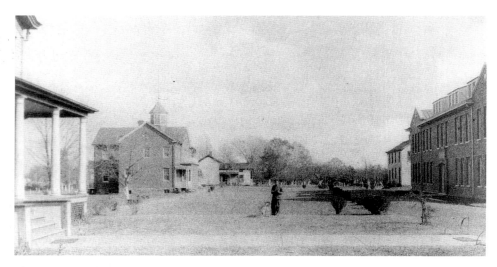

The Manassas Industrial School for Colored Youth opened in 1894. As Jennie Dean raised money, the school grew in enrollment and facilities. This postcard provides a glimpse of the campus in 1925. The large, brick building on the right side is the Carnegie Building (named for benefactor Andrew Carnegie), which housed academic and trade classrooms, the library, and administrative offices. On the left is Hackley Hall, the boys' dormitory. The porch of the girls' dormitory, Howland Hall, is visible in this photograph.

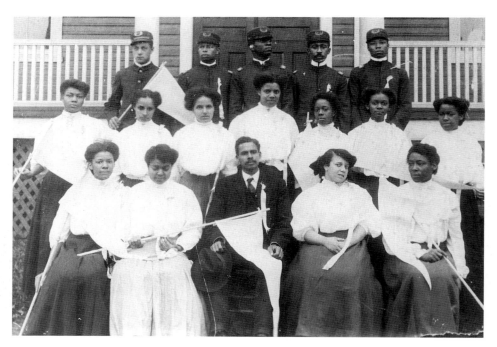

Students came from Northern Virginia, Washington, D.C., and at least ten other states to attend the Industrial School. Catering to both boarding and day students, the Industrial School provided a rare commodity—secondary education for African Americans. Dressed in their required uniforms, these young men and women graduated from the Industrial School in 1906.

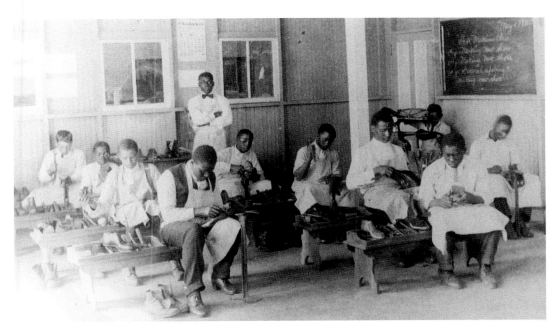

In addition to their academic training, students learned trades that they could practice later in life. Cobbling, seen here in 1911, was just one of the trades boys learned. They also became skilled in carpentry, farming, gardening, blacksmithing, wheelwrighting, bricklaying, painting, and printing.

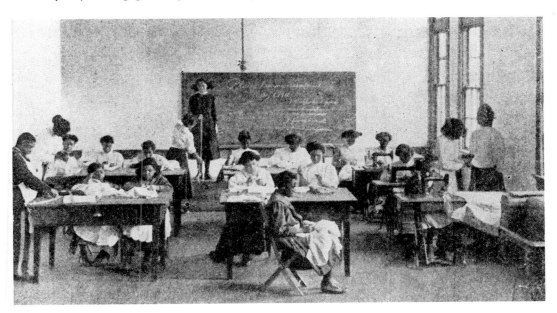

Girls also studied both trades and academics at the Industrial School. Their courses included sewing, cooking, housekeeping, laundry working, poultry raising, and woodworking. This 1914 class is learning to sew. The 1908–1909 school catalog describes the course as follows: "The work in sewing covers a period of four years, the primary course teaching the use of thread, thimble, needle, and giving instruction in such work as would come under the head of plain sewing."

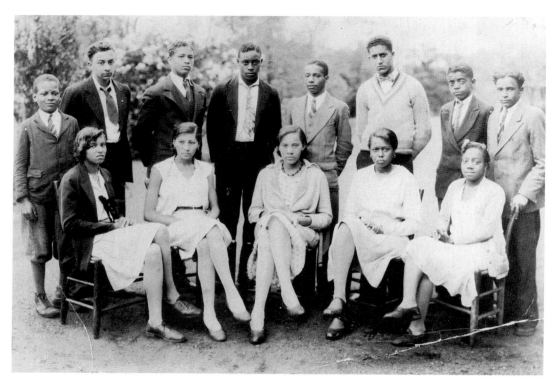

Above: Like their predecessors, the Freshman Class of 1931 came from great distances to attend the Industrial School. By that year the tone and mission of the school had changed. Students in 1931 did not wear uniforms as previous classes had. Also, the students focused more on academics than the trades that made up such a large portion of the curriculum in years past.

Opposite, above: In 1938, the Manassas Industrial School for Colored Youth officially closed, but out of its long tradition of African American education, the Manassas Regional High School was born. That year, Prince William, Fairfax, and Fauquier Counties agreed to purchase the Industrial School and operate it as a regional public high school for African Americans. The Carnegie Building, seen here in 1953, continued as the home of the Regional High School until 1959.

Opposite, below: By 1954, Fairfax and Fauquier Counties decided to build their own African American high schools, leaving Prince William as the sole owner of the Regional High School. Following this move, Prince William County consolidated its African American students, moving the elementary grades to the Regional High School building. In 1959, the County built a new school for its African American students next to the former Industrial School buildings—Jennie Dean High and Elementary School. In this photograph from c. 1960, former Industrial School students gaze from the front of Howland Hall at the new Jennie Dean School. Prince William County desegregated its schools in 1966, and the Jennie Dean School became solely a high school. The City of Manassas then assumed control of the school in 1977, changing it first to Jennie Dean Middle School and finally in 1991 to Jennie Dean Elementary. During the 1960s, the original Manassas Industrial School buildings were torn down. In 1995 The Manassas Museum System opened the Manassas Industrial School/Jennie Dean Memorial on the site if the original buildings.

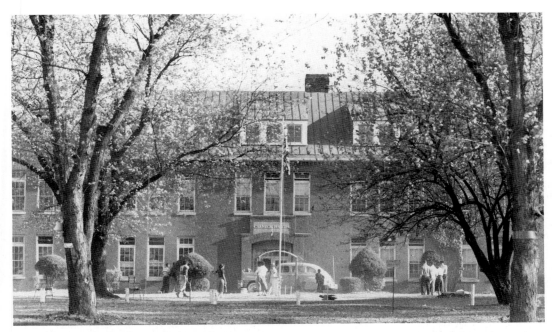

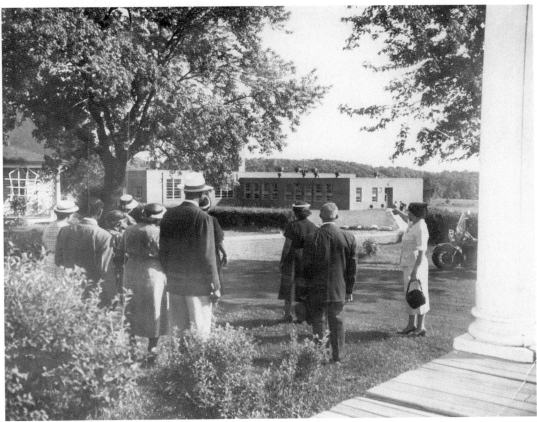

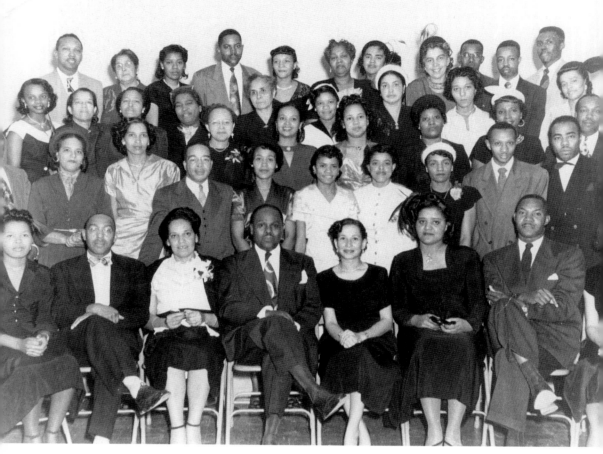

Prince William County has a strong tradition of employing African American educators. Teaching in Prince William County could often be a trying experience for these men and women, however, because county schools were separate but definitely not equal. African American teachers had to struggle for equal funding, facilities, and supplies. The dedicated men and women pictured in this January 1954 photograph devoted their lives to educating the county's African American students. Schools like the Brown School, Manley School, Lucasville School, and the Regional High School, to name just a few, engaged these teachers and their predecessors in the instruction of African American youth. From the time this photograph was taken, another 12 years would pass before the schools in Manassas and Prince William County integrated.

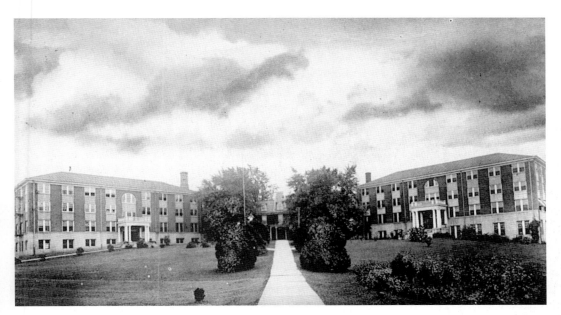

Between 1909 and 1935, two colleges and a college preparatory school operated out of these buildings south of the railroad tracks. In 1909, Eastern College, a four-year school offering degrees in a number of fields, opened in Manassas on Isaac Baldwin's property. To accommodate its enrollment, the college built two brick buildings, East Hall and Vorhees Hall, the men's and women's dormitories, respectively. Initially, the college prospered, but following WW I its debts were too great, and the school closed. For a short period, a girls' school, the Eastern College-Conservatory, occupied the buildings but it also failed. From 1924 to 1935, Eli Swavely ran a boys preparatory school on the site. Then Prince William County took over the buildings and attempted to make it a vocational school; however, the endeavor failed. The abandoned buildings posed a threat, and the County razed them in 1966. In 1991, The Manassas Museum opened its new building on the site.

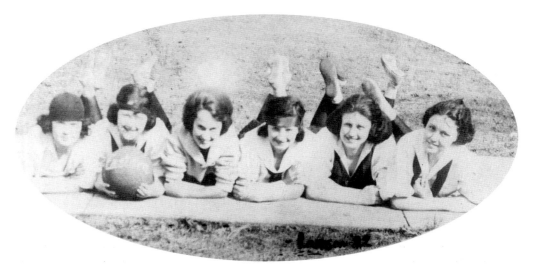

Eastern College attracted students from the Manassas area, other parts of Virginia, and at least 21 other states. Like most schools, Eastern offered a wide range of extracurricular activities and athletics in addition to its academics. The young ladies in this photograph joined in those activities during their time at Eastern. From left to right the women are Jack Morgan, Thelma Wolfe, Thelma Bell, Lucille Dorough, Dessie Nichols, and Viola Sarles.

Eli Swavely of Washington, D.C., opened the Swavely School in Manassas in 1924. The college preparatory curriculum prepared boys for the service academies at West Point and Annapolis. Swavely had an excellent faculty and a rigorous course of study. The Depression years, however, hit Swavely School hard, and by 1929, the school had amassed large debts, forcing it to close in 1935.

six

Faces of
Manassas

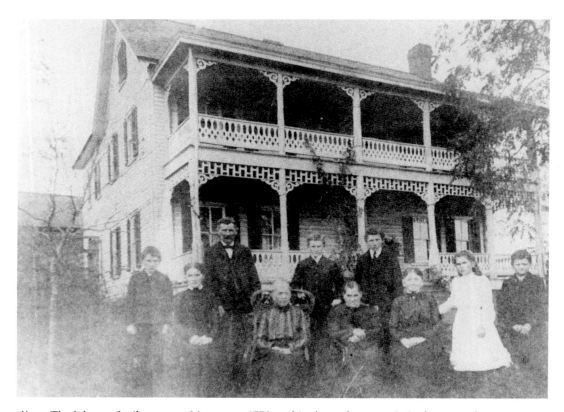

Above: The Johnson family came to Manassas c. 1770, and its descendants remain in the area today. Before the Civil War, their farm "Clover Hill," comprised about 1,400 acres. Like other residents of the Northern Virginia Piedmont, they expected prosperity from the newly built railroad. Instead, the war forced them from their home for several years. When they returned, their house and farm were in ruins. Emily Eliza Johnson and her family put the devastation behind them and rebuilt. This 1904 photograph shows the prosperous Johnson family in front of their house, built c. 1883. During the twentieth century, Johnson family members successfully ran a dairy farm and contributed to the Manassas community in many ways. In 1988, the Johnsons sold "Clover Hill," one of the last farms still operating in Manassas. Several shopping centers and the Wellington and Georgetown South housing developments sit on former Johnson farmlands.

Opposite, below: Born in the early twentieth century, Elvere, Virginia, Edgar, and Walser Conner spent their childhood days in Manassas. As adults, they all made their homes and raised their families in the Manassas area. Like their parents, E.R. and Anna Newman Conner, all four children contributed significantly to the civic and social life of Manassas.

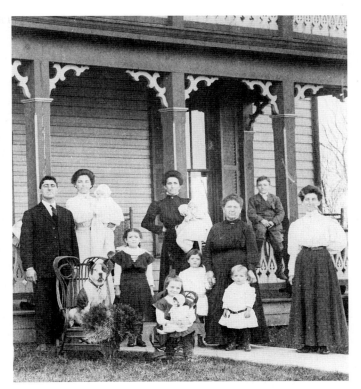

Right: The Conners are another family with deep roots in Manassas and Prince William County. Like the Johnsons, the Conners lived in the area before the Civil War. Here members of the Conner family stand in front of their home "Lebanon Hall" in 1911. E.R. Conner, pictured with his immediate and extended family, ran a successful meat market, owned a prosperous dairy farm, built the Conner Opera House, and served in state and local government. Conner descendants still live in Manassas.

Joseph Hottle and family, members of the Brethren Church, made their home near Cannon Branch, west of Manassas. Seen here in 1905, the Hottles were part of a movement in the 1870s that brought new families into the Manassas region in search of cheap land. Among them were the German Baptist Brethren, who migrated from the Shenandoah Valley. The Brethren sent several members of a congregation to establish homesteads in Northern Virginia. Others soon followed. Excellent farmers, with a strong commitment to education, the German-speaking Brethren at first lived in their own communities, but later dispersed throughout the region.

The Portner family was like no other in Manassas. They were not farmers from before the war, brethren from the Valley, or newcomers from the North. They were summer residents. German immigrant Robert Portner, seen here with his family in 1898, built a brewing and shipping empire in Alexandria, Virginia, by the 1870s. An incredibly wealthy man, Portner sought a summer home in the country, and he chose Manassas. He built "Annaburg," an estate and house of tremendous beauty and size. Gradually, the Portner family, including Robert's wife, Anna, and their children, spent more time at "Annaburg," and Robert expanded his business dealings in Manassas. He built the Prince William Hotel, funded construction of the Masonic Temple, and operated two stone quarries. Robert died in 1906 and Anna in 1912. Shortly thereafter, the Portner family left Manassas.

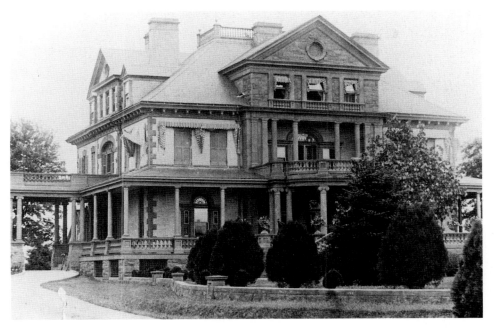

Robert Portner's "Annaburg," seen here in the early twentieth century, was the grandest house ever built in Manassas. Situated on 2,000 acres, the 35-room mansion completed in 1894 contained the most modern conveniences, including bathrooms, electric lights, and air conditioning. A 25-acre park with a goldfish pond, swan pond, swimming pool, vineyard, and gardens surrounded the house. Today, "Annaburg" is part of an adult-care facility in Manassas.

It was a grand affair, the wedding of Frances Bushong to Sedrick Saunders in 1935. The bridal party, dressed in the latest 1930s fashions, posed for this photograph in front of the bride's house. From left to right, the party is J. Jenkins Davies, Madeline McCoy, Hawes Davies, Rose Ratcliffe, Lowery Saunders, W. Sedrick Saunders, Frances Bushong, Rena Bevans, Jack Merchant, Esther Warren Pattie, Wallace Lynn, and Walser Conner. (Courtesy of William F. Merchant.)

On New Year's Eve, 1944, Edgar Rohr married Walser Conner, forming a union that benefited Manassas in many ways. Mr. and Mrs. Rohr devoted their lives to enjoying and improving the town they loved dearly. They owned the beloved Rohr's 5¢ to $1 store and Rohr's Museum. When not running his store, Edgar involved himself in town government, serving on the town council from 1951 to 1959 and again from 1965 to 1981. He then became mayor, holding office from 1981 to his death in 1988. Walser Rohr also dedicated her life to the Manassas community. She served in some of the most active civic groups, including the Manassas Garden Club, the Manassas Junior Woman's Club, the Woman's Club of Manassas, and the Manassas Volunteer Fire Company Auxiliary. Additionally, she is credited with starting The Manassas Museum. For her hard work and devotion, Manassas honored Walser in 1973 by naming her "Living Woman of the Century."

James and Marion Payne, pictured here during WW II, made Manassas a better place through their civic efforts. James Payne served for 34 years on town and city council and as vice mayor. He also contributed to Manassas by serving on the Airport Commission, the Utilities Commission, and as an advisor to the mayor. Marion Payne, a dedicated community activist, complemented her husband's governmental work with her cultural efforts. Her involvement included the Junior Woman's Club, the Manassas Garden Club, the Prince William Hospital Auxiliary, and the Manassas Historical Committee. During her tenure on the Historical Committee, The Manassas Museum opened its new building and added more sites to the Museum System.

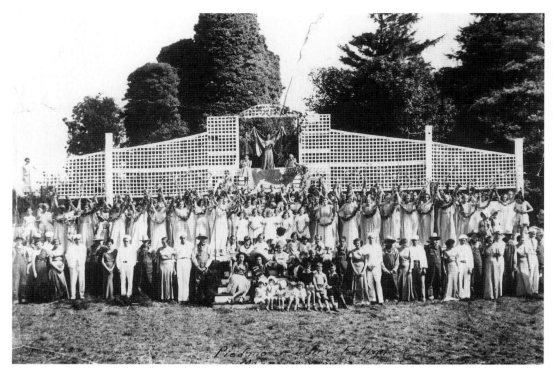

Above: Got milk? That is what all of Northern Virginia wanted to know in the 1930s, the height of the region's dairy farming. Nine counties and three cities in Northern Virginia banded together and created the Piedmont Dairy Festival. The annual event promoted the consumption of milk, educated people about the nutritional value of milk, and improved dairy herds. For two days, each fall between 1931 and 1936, Manassas hosted the Dairy Festival and its thousands of visitors. Highlights included the coronation of the Queen of the Festival, a dairy pageant, and a parade. Coronation of the Festival Queen and her court took place at "Annaburg," the Portner family estate. Here, in October 1935, the Queen, her court, milkmaids, and pageant participants pose for a photograph at "Annaburg." Each festival culminated with the Queen's Ball, attended by people from all over Northern Virginia.

Opposite, above: The Dairy Festival provided great entertainment each year, and the milkmaids played an important role. In 1935, a few of the milkmaids from the Fifth Piedmont Dairy Festival posed for this photograph, wearing their costumes. They are, from left to right, Edith Caudle, Martha Grimes, Louise Bryant, Thelma Breeden, Hilda Lion, Naomi Smith, and Jessie Lee Bolding.

Opposite, below: While the Dairy Festival provided great entertainment, it also had a more serious educational purpose. The participating counties wanted to spread the word about dairy farming and the benefits of milk. "The Big Gun of Health," in the shape of a milk bottle, was one component in that educational campaign. Betty Jane Nelson posed by the Big Gun in 1935.

Here comes the bride? The Manassas Kiwanis Club held the Womanless Wedding on November 15, 1938, to benefit underprivileged children. Held in the Manassas High School auditorium, the wedding featured some of Manassas' leading citizens. A reception and dance followed the nuptials. Billed as "a thousand and one laughs," the entire evening cost 35¢.

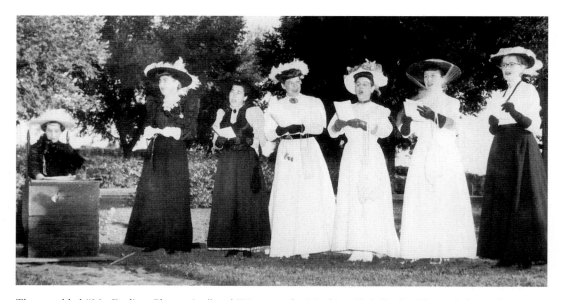

They warbled "My Darling Clementine" and "Listen to the Mocking Bird Sing" with good cheer all across Virginia. They were the "Gay Nineties" singing group made up of Dot Byrd, Virginia Ratcliffe, Walser Rohr, Frannie Saunders, Kitty Arrington, Gilley Kincheloe, and Libby Lynn. Formed on Pearl Harbor Day, the Manassas Junior Woman's Club began singing regionally for Kiwanis Clubs, Masons, politicians, and local army groups during WW II.

For children in Manassas, Halloween meant the annual Kiwanis Halloween Party held at the Manassas High School. The Kiwanis awarded prizes in categories like funniest, prettiest, and scariest costume. This group, in about 1946, posed at the party, showing off the latest in costumes that year—pirates, Robin Hood, and Raggedy Ann.

The clink of a misplayed note and the clunk of a key struck too hard—these were some of the sounds piano teacher Kitty Baker heard each day as she taught Manassas' youth how to play. After much practice, the notes became perfect, and the students played their pieces flawlessly at recitals. Here a group of Manassas youngsters poses after an early 1950s recital. (Courtesy of Ann Harrover Thomas.)

Above: Granny Hersch's mobcap and welcome sign greeted children at the Fun Farm for more than 20 years beginning in 1966. The Fun Farm, created by Orville and Mabel "Granny" Hersch, was a field trip destination for local schoolchildren, who arrived by the busload for a taste of farm life. The Herschs asked only one thing of the children who visited—a donation to the Heifer Project International. The Heifer Project is a charity that provides livestock and education to poor communities throughout the world. Until the 1980s, when both the Herschs passed away, the farm raised thousands of dollars for the fund and educated and entertained thousands of children. For children in the Manassas and the Northern Virginia area, "Granny" and Orville Hersch represented kindness, generosity, and the simple ways of life.

Opposite, above: Baseball is America's pastime and is played all over the country in local parks and giant stadiums. In every town in America, young boys dreaming of growing up and playing in the major leagues started in little leagues. Manassas had its share of little league teams, including this 1957 team sponsored by Manassas Lumber Corporation. (Courtesy of Ann Harrover Thomas.)

Opposite, below: Bands, floats, antique cars, fire engines, and local officials each year make up the Greater Manassas Christmas Parade, an event not to be missed. Held for decades, the Christmas Parade has become a much-anticipated annual family event. In 1952, just like today, children waited anxiously for the end of the parade to catch a glimpse of the jolly old elf himself, Santa Claus.

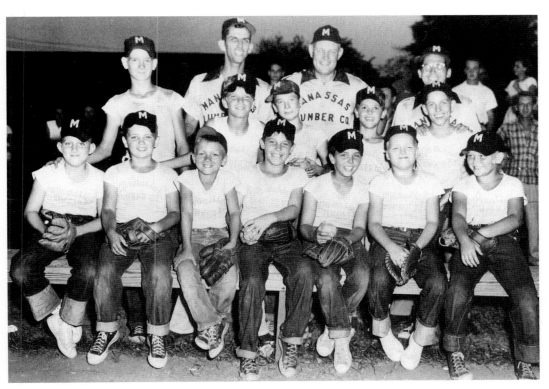

Above: After a hard day's work on the farm, in the factory, or in a store, the young men of the Manassas Band gathered together to practice at Nichol's Hall. At the turn of the twentieth century, the Manassas Band held concerts, marched in parades, and played conventions. Here the band leads a parade down Main Street at the turn of the twentieth century.

Left: J. Ivan Randall, left, and Jesse M. Bell, right, marched with their fellow band members in many parades. Frequently, they participated in the Washington's Birthday Parade in Alexandria. Dressed in their official band uniforms, Randall and Bell posed for this picture in August 1909.

Opposite, above: For $1 in 1936, Manassas residents could take an exciting airplane ride at the Manassas Landing Field on Sudley Road. Pilot F.B. Compton stands at the four-year-old airport looking out over the fence. The easy part was taking the plane ride; the difficult part was climbing over the fence because the airport had no gate.

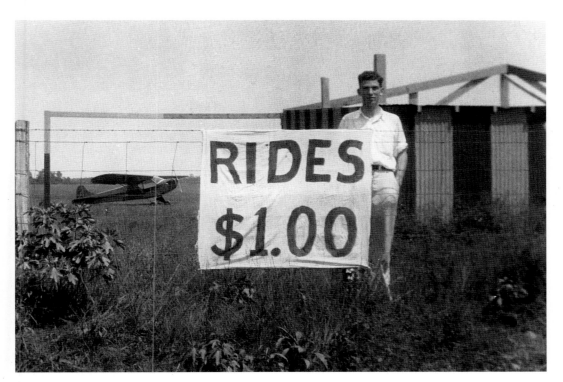

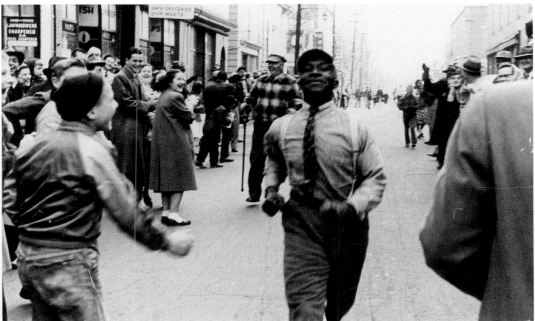

On your mark, get set, go! With those words, Philip Long took off up Center Street in an exhibition of his speed. Long, an unordained minister and Cocke's Pharmacy employee, was fast, running well into the last years of his life. He is seen here in the 1940s.

Perched proudly upon his roadster, Clarence Bryant posed for this picture in 1914. Clarence had a right to be proud. At that time, few Manassas residents owned cars. Horses still carried most people. Driving around Manassas on dirt roads full of holes and standing water must have taken the will of a devoted motorist.

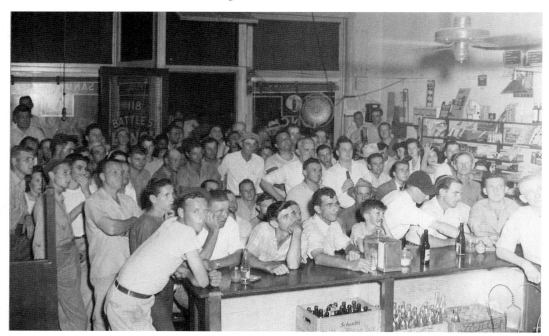

On a hot June night in 1948, it was standing room only at the Battle Street Lunch. The large crowd that squeezed into the small beer joint and pool hall intently watched a boxing match on the television. Cold suds and blowing fans provided the only relief for this capacity crowd.

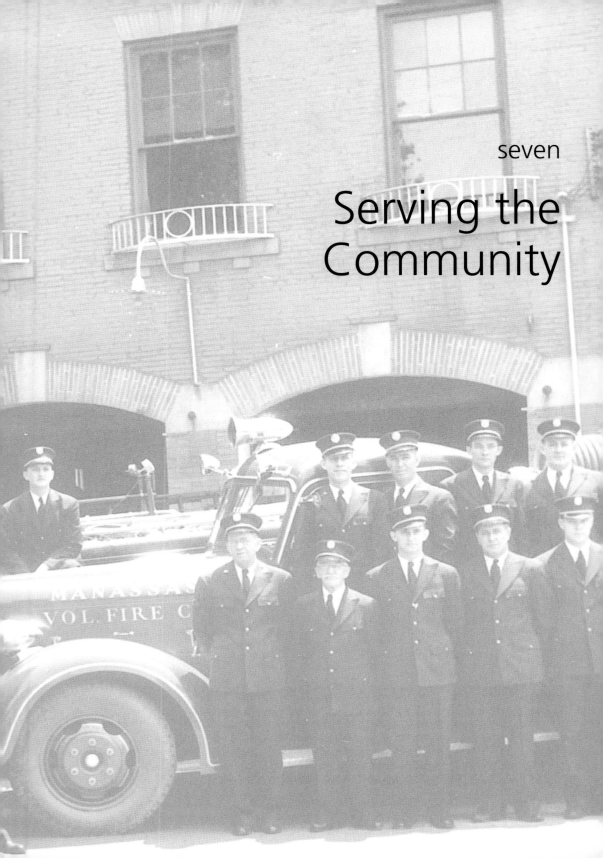

Serving the Community

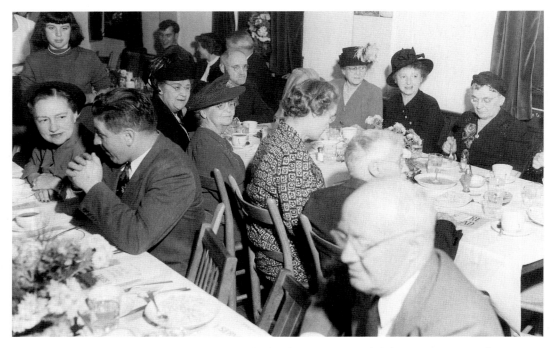

A church supper, like this one at Trinity Episcopal Church in 1948, provided the congregation with worship and socialization. In small towns like Manassas, churches played an enormous role in the lives of its citizens. This is especially true in Manassas, where according to Ripley's Believe It or Not!, the town at one point had more churches per capita than any other in the country.

Above: Trinity Episcopal Church began as part of Dettigen Parish, which was established in 1744. The parish, however, did not have a church building in Manassas until 1888. The congregation quickly outgrew its first church (shown at left), and in 1922, a new sanctuary was built next to the original. This church, seen here in the early twentieth century, offered members much needed room. The congregation continues to meet in this structure, although many additions have been made over the years.

Opposite, above: Many occasions that families remember most, such as baptisms, marriages, and funerals, take place at church. One such occasion was the wedding of George Schultz and Beulah Kincheloe at Trinity Episcopal Church c. 1915. The happy couple and bridal party gathered together after the service to commemorate the occasion in a photograph. (Courtesy of Ann Harrover Thomas.)

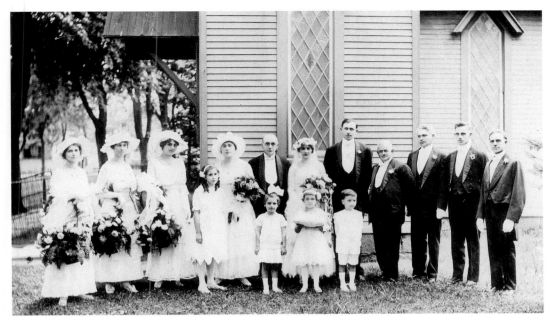

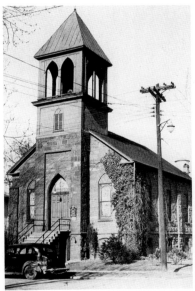

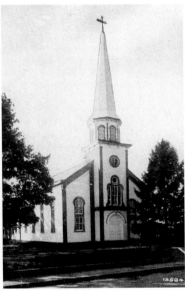

Above, left: The Presbyterian congregation in Manassas predates the Civil War, but it did not have a permanent home until 1875, when it built this structure. Pictured here in 1947, the Presbyterian church on the northeast corner of Main and Church Streets served the congregation for more than 100 years. In 1977, the Manassas Presbyterian Church moved into a new building on Ashton Avenue.

Above, right: All Saints Catholic Church on Center Street, seen here in the early twentieth century, is the oldest church in Manassas still in religious service. Built in 1879 by John Cannon, this building served the All Saints Parish until it built a new church on Stonewall Road in 1974. The structure then became the home of the Reformed Presbyterian Church.

Architect Albert Speiden, who lived in Manassas and commuted to his office in Washington, D.C., designed many of Manassas' turn-of-the-century buildings. Among his creations are the town hall, the National Bank of Manassas, the Hopkins Candy Factory, Trinity Episcopal Church, Manassas Baptist Church, and Grace Methodist Church, to name a few. At one time, Speiden could say that he had made plans or alterations for every church in Manassas. Albert Speiden was also a civic-minded man, serving on the town council and as chief of the fire department.

Above: The Manassas Baptist Church began in April 1884 with eight members. Shortly after its founding, the congregation met in a small frame building. In 1906, the Baptists replaced their old building with a new one on Center Street. Designed by Albert Speiden, the Baptist church seen here served its members until they moved to a new structure on the corner of Sudley and Stonewall Roads in 1967.

Right: Methodists worshiped in Manassas as early as 1867, but they did not have a church building until 1890. Outgrowing their original structure, the congregation built the Grace Methodist Church on the southwest corner of Main and Church Streets. Designed by Albert Speiden, the church, seen here in the 1930s, opened its doors in 1926. In the late twentieth century, the congregation moved to a new location on Hendley Road.

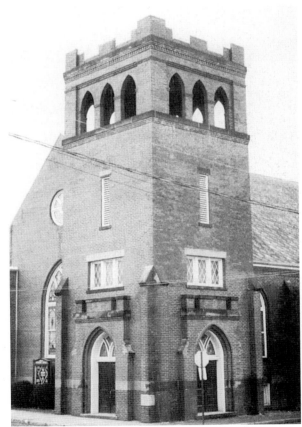

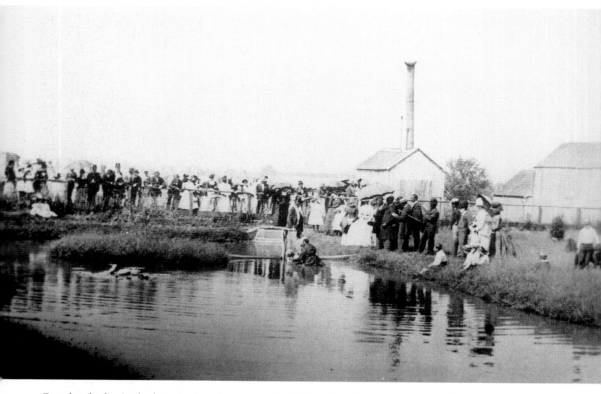

On a lovely day in the late nineteenth century, the African American congregation of First Baptist Church met at Deer Park Pond on the Portner estate "Annaburg" for baptism of its members. Reverend Marshall D. Williams, a founder of the church, immersed each new member in the waters. Reverend Williams and others, including Reverend S.W. Madden, organized First Baptist Church in July 1872. Unable to build a structure immediately, the group met in a small frame house on Liberty Street. In 1879, the church had enough money for a building and they constructed one on land donated by Isaac Baldwin. As they grew, the congregation required a larger structure, and in July 1905, the church moved to its current location on Center Street.

Right: The American Baptist Home Missionary Society sent Reverend Marshall D. Williams to Manassas to preach the gospel. He settled in Manassas and helped found First Baptist Church, the city's oldest African American congregation, in 1872. Reverend Williams spent the remainder of his career at First Baptist.

Below: The Deaconesses at First Baptist Church serve many vital functions for the congregation. They help prepare communion, provide the flowers, and set up for church services. In addition to this work, they also raise money for charity and general operations. The Deaconess Board of 1952 posed for this picture in the church's former sanctuary.

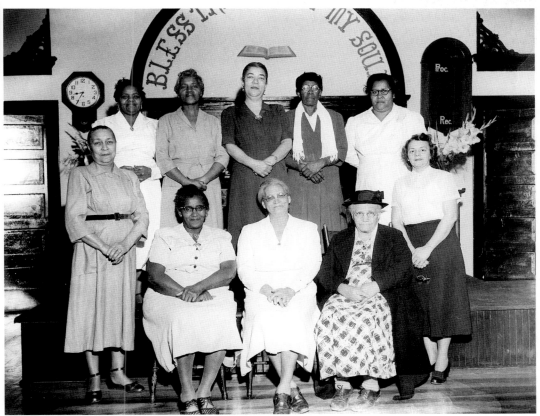

Dr. John D. Williams, son of Reverend Marshall D. Williams, devoted his life to medicine, education, and the people of Manassas. Born in Manassas in 1887, Williams attended the Brown School and the Manassas Industrial School. He left Manassas to earn his medical degree and returned in the 1910s to practice medicine. He spent his adult life healing the sick of Manassas, both African American and white, and championing African American education in Prince William County.

Dr. William Fewell Merchant, like Dr. Williams, served the people of Manassas. A town native, Dr. Merchant descended from the Fewell family, who initially owned much of the land that is now the City of Manassas. After completing medical school in 1897, Dr. Merchant returned to his hometown and led a successful practice until his death in 1924. In addition to his medical contributions in Manassas, he also involved himself heavily in civic life. (Courtesy of William F. Merchant.)

George Carr Round, a Union Army Signal Corps veteran and lawyer from New York, perhaps more than any other single person, helped create the town of Manassas. In 1868, after the Civil War, Round decided to seek his fortune in Virginia and settled in Manassas. He quickly became a strong advocate of education and was appointed the town's first superintendent of public schools. He also served as a member of the Virginia General Assembly, as a charter member of the Manassas Town Council, and as town clerk. Round organized the 1911 National Jubilee of Peace and was an advocate of the Manassas National Battlefield Park. By his death in 1918, Round had become one of the town's most beloved citizens, known for his encouragement of newcomers. The thriving modern community of Manassas is a living legacy to this gifted man. This photograph shows Round in 1910.

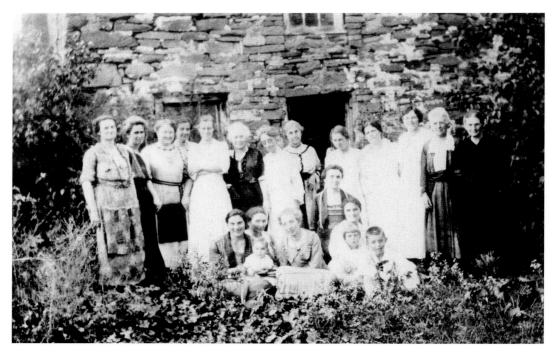

Above: "Learn to Live and to Perform" was the motto of the Bethlehem Club for 83 years. The Bethlehem Good Housekeepers' Club, founded in 1913 at the Johnson family farm "Clover Hill," had five objectives—social, educational, historical, charitable, and civil work. Using these objectives, the ladies actively involved themselves in county fairs, community service projects, and the publication of books. Funds from the club's treasury supported many organizations including the Red Cross, March of Dimes, nursing homes, the Eye Bank, and hospitals. The ladies also worked hard to preserve the history of Prince William County through the publication of the book *Prince William, The Story of Its People and Its Places.* Since its initial publishing in 1941, this valuable historical resource has had four reprints. Sadly, in 1996, the oldest women's club in Prince William County folded after years of charitable and social service. In 1921, club members posed at "Clover Hill" farm for this group portrait.

Opposite, above: Before the Bethlehem Club, the County Home Demonstration Club, and the 4-H, Manassas had the Tomato Canning Club. Ladies, pictured here in 1911, gathered together to socialize and learn how to can tomatoes. As interest in instructional and social clubs grew, the Bethlehem Club absorbed the Tomato Canning Club.

Opposite, below: The Ladies Auxiliary of American Legion Post 114 has been involved in the Manassas community for many years. Some of their charitable activities include preparing meals for veterans, visiting the elderly, and holding an annual Easter egg hunt. Part of their social activities in the mid-twentieth century included holding a ball and crowning a queen. Queen Estelle Douglas Moore and her court posed in 1954 for this picture.

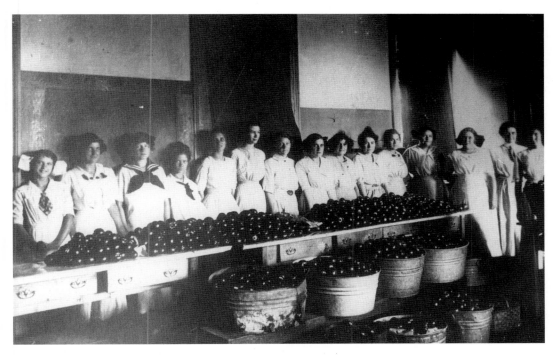

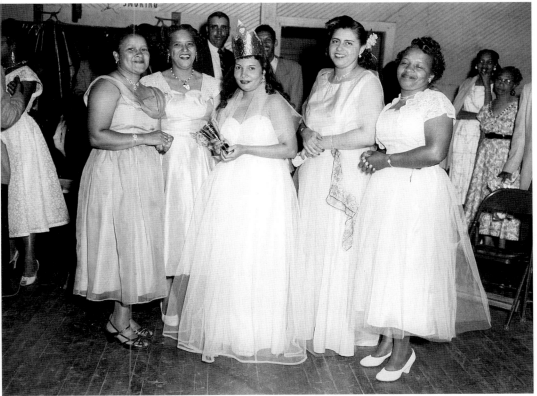

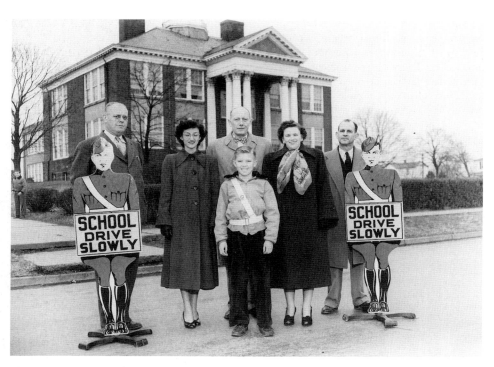

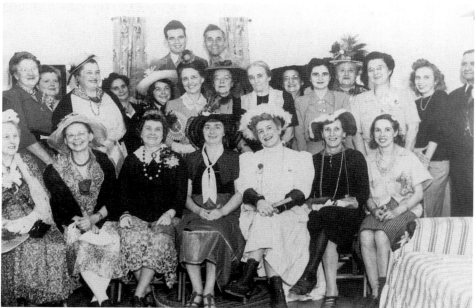

The Manassas Woman's Club, founded in 1926, has served the community for decades. Organized to promote the civic and cultural welfare of the community, the club provides charitable donations and educational scholarships. In addition to its philanthropic mission, the club is also a wonderful social activity for local ladies. These members in 1946 enjoyed a whimsical evening together.

Opposite, above: The Junior Woman's Club of Manassas began in 1931 with 13 members. It worked then and now for social advancement and cultural development. One of their primary objectives is to support education through scholarships and projects. In 1950, the Juniors helped fund and promote school safety. Here, representatives of the Junior Woman's Club and the school system stand in front of Bennett School with safety signs the club donated.

Right: One of the oldest fraternal orders in the United States, the Masons have long been a part of the Manassas community. Dr. V.V. Gillum, a local dentist, belonged to the Manasseh Lodge, No. 182, A.E. & A.M. In this 1915 photograph, Dr. Gillum models his full dress uniform. The Masons erected a Temple on Center Street in 1906 with money donated by Robert Portner.

Below: Each year, needy young people in Manassas get new glasses, eye operations, and seeing-eye dogs because the Manassas Host Lions Club cares. Begun in 1948, the Lions Club is dedicated to community service, especially helping those who have difficulty with their vision. The 1948 officers of the newly formed club posed for this picture. At that time the club had about 21 members.

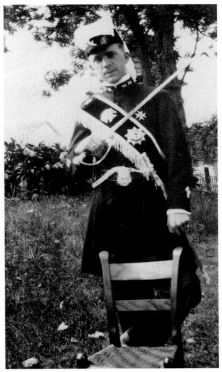

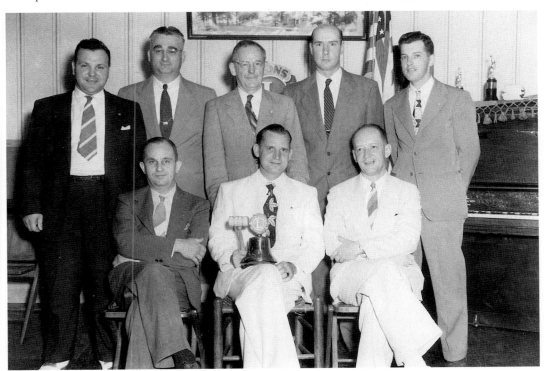

The mail must go through, and Howard P. Young made sure in early-twentieth-century Manassas that it did. This photograph taken in 1915 shows Mr. Young on his route just outside Manassas. At that time, U.S. Mail Parcel Post came by horse and wagon.

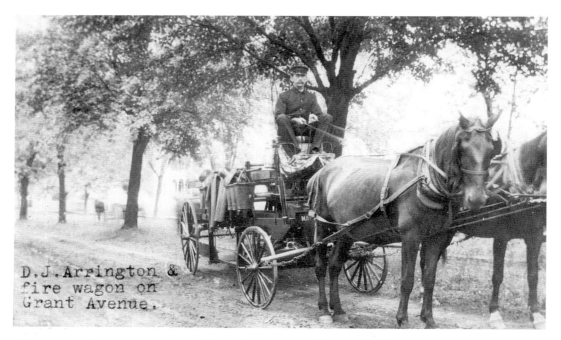

Just as horse and wagon first transported the mail, it also carried the first firefighting equipment in Manassas. Volunteer firefighter D.J. Arrington is seen here driving the fire wagon down Grant Avenue in the early twentieth century. Firefighting apparatus are exhibited today at the Manassas Volunteer Fire Company Museum.

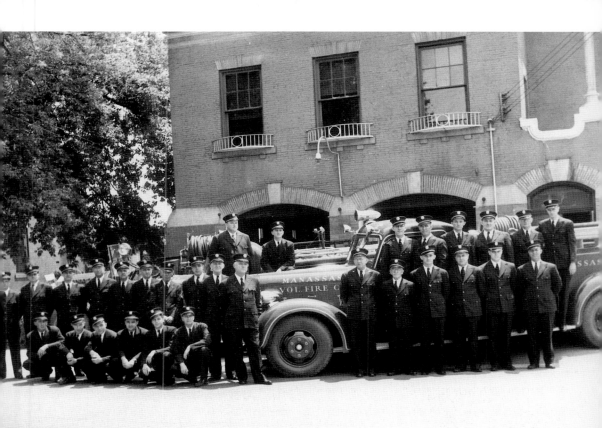

In 1892, the citizens of Manassas banded together to create a firefighting organization. The result was the Manassas Volunteer Fire Company (MVFC), the first fire company in Prince William County. They started with a few buckets and ladders, which they kept at the train station because they did not have a firehouse. In 1914, the company obtained its first permanent home, the first floor of Manassas Town Hall. This 1948 photograph shows the fire company posed in front of town hall. In 1956, the company moved to its new and current location on Centreville Road. Today the MVFC continues to protect Manassas citizens in times of fire. The company is very active and in 1996 created a museum to commemorate and teach the community about the history of firefighting in Manassas.

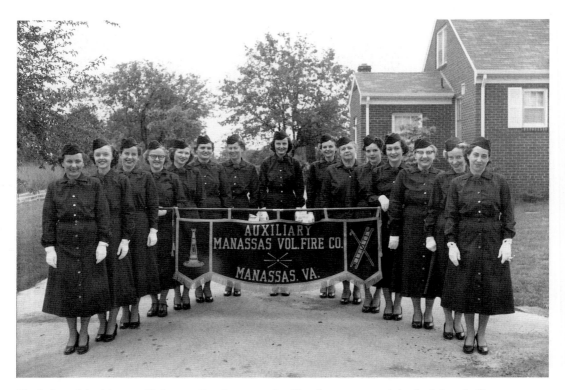

The ladies of the Manassas Volunteer Fire Company Auxiliary have supported the firefighters' efforts since the 1940s. Initially, the ladies made coffee and food for firefighters when they were battling a blaze. Later the Auxiliary evolved into a fund-raising organization for the fire company. Over the years, the group has held dinners at the firehouse, participated in parades, and provided food for bingo on Saturday nights. In 1954, the members of the Auxiliary posed in their uniforms for this picture. The ladies are, from left to right, Eula Bourne, Becky Dowell, Mildred Watts, Goldie Mathias, Lorene Parrish, Eleanor Hynson, Edna Earl Kincheloe, Lois Brown, Henrietta Jussaume, Orma Davis, Bibs Wheeling, Bea Barron, Ruth Slusher, Mattie Parrish, and Walser Rohr.

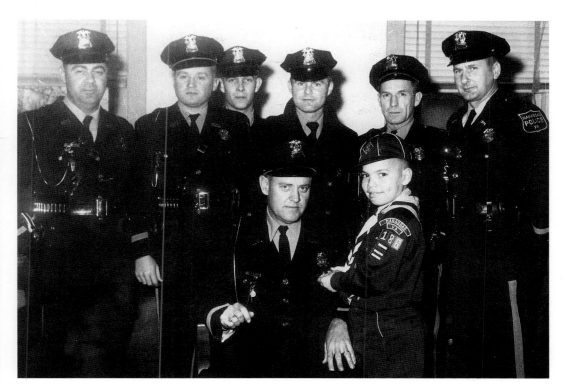

When Manassas incorporated as a town, the citizens laid the groundwork for the present-day police force. In addition to the mayor, councilmen, and town clerk, the citizens also elected a town sergeant, who served as the law enforcement officer. As the population grew, so did the police force. Between 1910 and the 1960s, the expanding police department had its offices in the town hall building and its annex. In 1971, the much larger force moved to its current location on Fairview Avenue. Over the years, many officers have protected the town and city of Manassas. A few of the officers who served in the 1950s include, from left to right, the following: Smilie Hobbs, Clark Nalls, Richard Schultz, Gene Brown, Luther Cox, C.K. Lyles, and Chief Bernie Reed (seated).

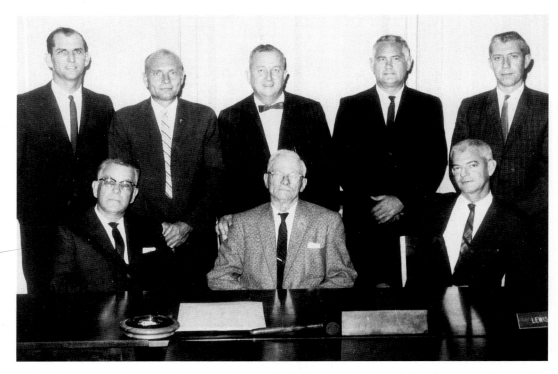

When Manassas became an incorporated town in 1873, the people elected their first mayor, Robert C. Weir. Many men have held the office over the years, but none as long as Harry P. Davis. In 1921, Davis took over as mayor of Manassas and continued in this office for 44 years, leaving in 1965. Under his leadership, Manassas grew from a small agricultural community to a bustling suburban center. Also, through his guidance, Manassas switched in 1927 to a town manager form of government. During his last term, Mayor Davis posed with the 1963 town council. Sitting in the front row, left to right, are Orrin Kline, Mayor Davis, and Harry Parrish. In the back row, left to right, are Stewart Vetter, Garnett Carpenter, James Payne, Robert Byrd, and Eugene Worley.

Acknowledgments

I owe a special debt of gratitude to the many people and organizations that helped me prepare this book: the staff of The Manassas Museum System, which includes Donna Barker, Scott Harris, Jo Matthews, Dave Purschwitz, and Laura Peake Yakulis; The Manassas Museum Associates, especially Nancy O'Brien and Jane Riley; Ann Harrover Thomas; Celestine Braxton; Lewis and Rosalie Leigh Jr.; William F. Merchant; Georgia Peters Goodwin; Michael Winey at the United States Army Military History Institute; the Library of Congress; the National Archives; and the Western Reserve Historical Society.

Note: Full credit for images listed as MOLLUS/USAMHI is Massachusetts Commandery Military Order of the Loyal Legion and the United States Army Military History Institute. Images listed as MOLLUS/USAMHI is Massachusetts Commandery Military Order of the Loyal Legion and the United States Army Military History Institute.